Into the Quiet and the Light

In South Louisiana, situated where the Mississippi River meets the Gulf of Mexico, water – and the history of controlling it – is omnipresent. *Into the Quiet and the Light: Water, Life, and Land Loss in South Louisiana* glimpses the vulnerabilities and possibilities of living on the water during an ongoing climate catastrophe and the fallout of the fossil fuel industry – past, present, and future. The book sustains our physical, mental, and emotional connections to these landscapes through a collection of photographs by Virginia Hanusik. Framing the architecture and infrastructure of South Louisiana with both distance and intimacy, introspection and expansiveness, this work engages new memories, microhistories, anecdotes, and insights from scholars, artists, activists, and practitioners working in the region. Unfolding alongside and in dialogue with Hanusik's photographs, these reflections soberly and hopefully populate images of South Louisiana's built and natural environments, opening up multiple pathways that defy singularity and complicate the disaster-oriented imagery often associated with the region and its people. In staging these meditations on water, life, and land loss, this book invites readers to join both Hanusik and the contributors in reading multiplicity into South Louisiana's water-ruled landscapes.

Into the Quiet and the Light

Water, Life, and Land Loss in South Louisiana

Virginia Hanusik

Indeterminate Landscapes
Virginia Hanusik

Living things don't all require
light in the same degree. Some of us
make our own light: a silver leaf
like a path no one can use, a shallow
lake of silver in the darkness under the great maples.
 — Louise Glück, "Lamium"[1]

I.

In 1948, a film about a young Cajun boy and his pet raccoon navigating
an idyllic existence, mostly by boat, was made and set in the bayous of
South Louisiana. The plot revolves around the boy's family who allows an
oil company to drill in the inlet that runs behind their home. As the story
progresses, the company completes its operation and the friendly drillers
depart, leaving behind an untouched, pristine environment and a newly
wealthy family.

Louisiana Story was nominated for an Academy Award for
Best Writing in a Motion Picture Story in 1948, and in 1994 it was added
to the United States National Film Registry by the Library of Congress
for being "culturally, historically, or aesthetically significant."[2] The film
portrays the petrochemical industry in symbiotic harmony with people
and the environment, ultimately implying that oil's machinery is a benign
force — a message with a pernicious agenda considering that the film was
funded by the Standard Oil Company to promote its drilling ventures in
Louisiana's waterways.

It is one of many works reminding us that landscape
representation is not neutral. It is both an inherently subjective and
affective medium — connecting with and influencing our relationships,
associations, and attitudes toward particular places. As in the film, cameras
are often employed to construct a broader narrative beyond the frame,
portraying land as a part of the human story. To talk about land and
how we view it is to talk about how we view ourselves and each other. In
Louisiana, the exploitation of land — its resources and its people — is
connected to larger legacies of how we see space and how that act of
looking has long been leveraged as
a propagandistic tool.

This book
brings together a collection
of my photographs that

1 Louise Glück, "Lamium," in *The Wild Iris*
(Hopewell, NJ: Ecco Press, 1992), 5.

2 "25 Films Added to National Registry," *New
York Times*, November 15, 1994, https://www.
nytimes.com/1994/11/15/movies/25-films-
added-to-national-registry.html.

Indeterminate Landscapes
Virginia Hanusik

Living things don't all require
light in the same degree. Some of us
make our own light: a silver leaf
like a path no one can use, a shallow
lake of silver in the darkness under the great maples.
— Louise Glück, "Lamium"[1]

I.

 In 1948, a film about a young Cajun boy and his pet raccoon navigating
an idyllic existence, mostly by boat, was made and set in the bayous of
South Louisiana. The plot revolves around the boy's family who allows an
oil company to drill in the inlet that runs behind their home. As the story
progresses, the company completes its operation and the friendly drillers
depart, leaving behind an untouched, pristine environment and a newly
wealthy family.
 Louisiana Story was nominated for an Academy Award for
Best Writing in a Motion Picture Story in 1948, and in 1994 it was added
to the United States National Film Registry by the Library of Congress
for being "culturally, historically, or aesthetically significant."[2] The film
portrays the petrochemical industry in symbiotic harmony with people
and the environment, ultimately implying that oil's machinery is a benign
force — a message with a pernicious agenda considering that the film was
funded by the Standard Oil Company to promote its drilling ventures in
Louisiana's waterways.
 It is one of many works reminding us that landscape
representation is not neutral. It is both an inherently subjective and
affective medium — connecting with and influencing our relationships,
associations, and attitudes toward particular places. As in the film, cameras
are often employed to construct a broader narrative beyond the frame,
portraying land as a part of the human story. To talk about land and
how we view it is to talk about how we view ourselves and each other. In
Louisiana, the exploitation of land — its resources and its people — is
connected to larger legacies of how we see space and how that act of
looking has long been leveraged as a propagandistic tool.

 This book brings together a collection of my photographs that

1 Louise Glück, "Lamium," in *The Wild Iris* (Hopewell, NJ: Ecco Press, 1992), 5.
2 "25 Films Added to National Registry," *New York Times*, November 15, 1994, https://www.nytimes.com/1994/11/15/movies/25-films-added-to-national-registry.html.

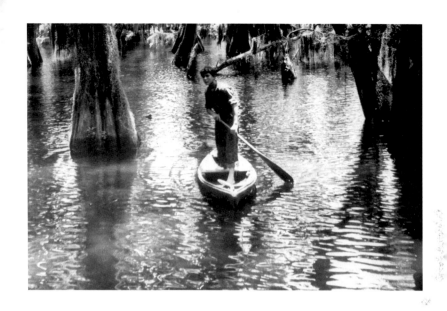

Boy rowing down the bayou, still from *Louisiana Story*, directed by
Robert J. Flaherty, 1948. Courtesy of Robert Flaherty Productions.

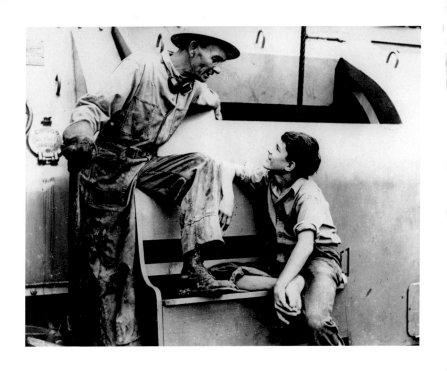

Boy and oil rig worker, still from *Louisiana Story*, directed by Robert J. Flaherty, 1948. Courtesy of Robert Flaherty Productions and RGR Collection via Alamy Stock Photo.

showcase the architecture and infrastructure of South Louisiana. It is uninterested in offering a superior way of seeing, but rather seeks to visualize and illustrate our relationships with coastal landscapes and the liminal spaces between land and water. These images are presented in tandem with written narratives that together unfold the spatial and spiritual qualities of moving through the world at a time of ecological collapse.

With my work, I am interested in parsing the complexity of living with a changing climate while advocating for the value of a place that is often seen by the rest of the country as a sacrificial climate buffer zone. The environmental parameters we are forced to reckon with today emphasize how living along the water will look increasingly different in the coming decades — especially as invisible infrastructures like flood insurance continue to alter the landscape. By focusing on the architecture, landscape, and infrastructure of South Louisiana, my images illuminate how we've altered the land through shortsighted technical measures and have thus chosen to protect certain communities over others.

Massive feats of human engineering such as the multibillion-dollar Lake Borgne Storm Surge Barrier, nicknamed the "Great Wall of Louisiana," are pictured alongside more patchwork, individualized approaches to climate change adaptation in communities outside of the levee protection system. My pictures challenge the concept of "resilience" as it has been used to describe communities who are left to pick up the pieces from a system that has often failed to protect them. I've approached photographing these structures as a way to understand and analyze human nature: how ideas around ownership, community, and identity are manifested across the built environment. The idea and practice of controlling water has been and continues to be a critical part of Louisiana's modern history. Who has controlled it and what purpose it serves reflects greater ideas about the perceived value of property and of people.

As stronger hurricanes, rising sea levels, and the fossil fuel industry threaten the existence of the coast as we know it, how will our physical, mental, and emotional connections to these landscapes be maintained? Can the architecture of these places promote ways of living and building that are more attuned to the nurturing of coastal ecosystems — both environmentally and culturally? And as we emerge into the environmental

unknown, how might we visualize, narrate, and imagine different stories for South Louisiana?

II.

The year 2019 marked the first time in over forty years that Louisiana was the focal point of a landscape exhibition and the first time that Louisiana landscape painting was placed in a wider national and international context.[3] Titled *Inventing Acadia: Painting and Place in Louisiana*, the exhibition was hosted by the New Orleans Museum of Art and explored the advent of landscape painting across Louisiana in the nineteenth century. It was described by curator Katie Pfohl as "both an act of recovery, and a recognition of loss. Because these paintings have, up until recently, been less widely known, they have not been as carefully researched, documented, and preserved as landscape painting from other places."[4] This omission from the art historical record hints at the profound marginalization of Louisiana's geographies and ways of life in the United States' consciousness—an exclusion that continues to impact the present.

The practice of visually representing land has been critical to the construction and endurance of American identity and United States nation-building. Beginning with the Hudson River painters of the early nineteenth century, landscape representation became synonymous with ideas of growth and prosperity. Paintings like *Catskill Creek, New York* (1845) by

3 Katie A. Pfohl, ed., *Inventing Acadia: Painting and Place in Louisiana*, exhibition catalog, (New Orleans: New Orleans Museum of Art, 2019), 11.
4 Pfohl, *Inventing Acadia*, 13.
5 See Edmund Burke, *A Philosophical Enquiry into the Origin of our Ideas of the Sublime and Beautiful and Other Pre-Revolutionary Writings* (London: printed for R. and J. Dodsley, 1757). For landscape painters, the sublime was essentially the evocation of awe and terror, the beautiful meant soft and aesthetically pleasing, while the picturesque—literally "in the manner of a picture"—was defined as irregular, ragged, and asymmetrical. Hudson River paintings were primarily picturesque and marked the greater Catskill Mountain region as the epicenter of American landscape appreciation in the mid-to-late nineteenth century. See William Gilpin, *Three Essays: On Picturesque Beauty; on Picturesque Travel; and on Sketching Landscape: to Which Is Added a Poem, on Landscape Painting* (London: printed for R. Blamire, 1792).
6 In 1987, the Metropolitan Museum of Art organized an exhibition titled *American Paradise: The World of the Hudson River School*. The exhibition and corresponding catalog, well known by American art historians, was a critical event that further established the male painters of the Northeast as foundational to the representation and portrayal of landscape in America, omitting artists of different genders and whose work focused on different geographies.

Catskill Creek, New York, Thomas Cole, 1845. Oil on canvas, 26 ¹/₂ × 36 ɪɴ. The Robert L. Stuart Collection. New-York Historical Society, s-157. Digital image created by Oppenheimer Editions.

The Acadians in the Achafalaya, "Evangeline," Joseph Rusling Meeker, 1871. Oil on canvas, 31 ⅝ × 42 1/16 IN. Brooklyn Museum, A. Augustus Healy Fund, 50.118.

Thomas Cole helped define what was beautiful and what was "God-given" to Americans, establishing a sense of national identity and entitlement tied to a distinctly "unique" terrain. While Cole himself was witness to the encroachment of industrialization into the Catskills, in *Catskill Creek* he still chose to depict a pristine landscape, celebrating idealized aesthetics and visions of an untouched environment.

As the newly colonized continent was being cultivated, the discretionary power of beauty emerged alongside and through these forms of representation—which landscapes and sites are worthy of being celebrated and what makes an iconic American scene. Ideas around aesthetic ideals were largely influenced by European Romantic painters and philosopher Edmund Burke's 1757 writing on the sublime, which then led to the theory of the *picturesque* championed by British artist William Gilpin.[5] These theories helped establish a hierarchy of scenery in American landscape art that prioritized more mountainous terrains over flatter landscapes, valuing the composition of light and shadow that topography with a range in elevation provided. Despite being influenced by European painting, artists like Cole and Asher Brown Durand created a market for American scenery by conveying the beauty that existed separate from Europe, specifically Britain, in the wake of American independence.[6]

The value system attendant to landscape painting has been consolidated at the expense and degradation of other geographies that don't fall within these standards, like Louisiana's wetlands. Writing about the complicated history of landscape painting in Louisiana, Pfohl again notes that its wetlands in particular challenged and confused dominant and largely Western conceptions of what was considered a "proper" landscape. She describes:

> The painters who came to this region—from Europe, the Caribbean, and the broader Americas—encountered a landscape utterly unlike the mountains and valleys around which the very idea of landscape painting had been formed. In Louisiana, these artists travelled through boundless wetlands that barely looked like land at all, places that appeared, in the words of nineteenth century historian Charles Gayarre, "as if they wish to sink back into the sea, from shame of having come into the

world prematurely, before having been shaped and licked by nature into proper objects of existence." This radical indeterminacy made many wonder whether Louisiana could even be referred to as land, much less painted as a landscape.[7]

The Louisiana wetlands were placed into a broader history of describing and devaluing land deemed unfit for a specific use. Tracing the various incarnations of the term *wasteland*, architecture and art historian Vittoria Di Palma in her book *Wasteland: A History* established the term's importance in the construction of some of the most fundamental values associated with landscape. These biases have had tangible effects on the environment outside of their depiction and commodification. Describing geographies that have come to be characterized as "anti-picturesque," like swamps that have traditionally drawn fear and contempt, she emphasizes that "the concept of wasteland has – with both positive and negative consequences – enabled the formulation of a landscape ideal, influenced our management of natural resources, colored our attitudes toward newly discovered territories, and directed our attitudes toward pollution and waste."[8]

Swamps have a place in the historical collection of landscapes considered wastelands. In one of the most popular books ever printed, *The Pilgrim's Progress: From This World to That Which Is to Come*, the main character traverses an allegorical landscape to seek salvation.[9] In this work of theological fiction, first published in 1678, the swamp is presented as the Slough of Despond, a landscape at its most contaminated and polluted, "where the scum and filth that attends conviction for sin doth continually run."[10]

As it relates to the work of influential landscape artists such as Gilpin, Di Palma writes: "To an eye trained to evaluate landscape according to criteria of the picturesque, the Fens – or any marsh – offended by offering nothing to see."[11] She later continues, "A marsh, swamp, bog, or fen is neither earth nor water, solid nor liquid, and in its imprecision, its unsettling resistance to categorization, it harbors a particular charge."[12]

Despite – and perhaps because of – these biases, swamps, especially in Louisiana, also have a long history of providing refuge for those targeted by the violence of settler colonialism. For decades, formerly enslaved people found community with Native Americans and Maroon communities. Together, they learned to survive and adapt to

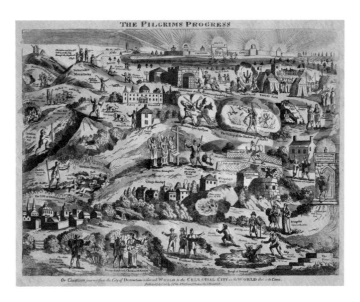

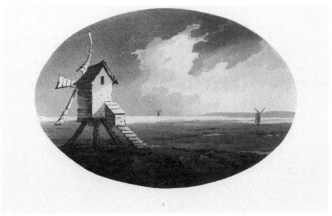

Top: *The Pilgrim's Progress*, John Pitts, 1813. Hand-colored etching, 14 4/5 × 18 4/5 IN. © The Trustees of the British Museum.

Bottom: *Landscape between Cambridge and Ely*, William Gilpin, 1809. Aquatint with hand coloring, 8 3/5 × 5 IN. © Royal Academy of Arts, London.

Yosemite Valley, California, Carleton Watkins, ca. 1865. Albumen silver print, 16 ¹/₄ × 20 ¹/₂ IN.

the 30,000 acres of southeastern wetlands adjacent to Lake Borgne known as the Louisiana Central Wetlands.[13]

III.

Landscape representation's relationship to the management of land in the United States further transformed as early photographers also became consumed with the documentation of nature. In fact, as photography became more popular in the late nineteenth century, it challenged painting as the "correct" medium for communicating "truth" – particularly as it relates to beauty, value, and opportunity. Photographic surveys created marketing collateral for what would later be used in the campaign for westward expansion. As American art historian Barbara Novak argues, the "artist-photographer" became "the provider of authentic evidence," as, unlike painting, the photograph appeared to be untouched by human subjectivity.

Novak's depiction of artist-photographers makes a distinction between this new medium and the traditional artistic methods of representing landscape.[14] Rather than being valued as a form of fine art, photography was originally used for documentary practices, a concept in and of itself that presents ethical questions relating to the photographer and the subject. The relationship between visual material and boundary setting grew as Americans moved westward and the need to claim the land and delineate ownership over its function increased. Photography practices at this time came to deeply impact the organization and management of terrain in the US as a settler colonial state.

The photographs Carleton Watkins made of California, for instance, influenced the federal protection of Yosemite Valley in the 1860s and were used in a later survey done by geologist Clarence King to define the boundaries of the park, which created a line

7 Pfohl, *Inventing Acadia*, 21.
8 Vittoria Di Palma, *Wasteland: A History* (New Haven, CT: Yale University Press, 2014), 11.
9 Robert McCrum, "The 100 best novels: NO 1 – The Pilgrim's Progress by John Bunyan (1678)," *Guardian*, September 23, 2013, https://www.theguardian.com/books/2013/sep/23/100-best-novels-pilgrims-progress.
10 John Bunyan, *The Pilgrim's Progress from This World, to That Which is to Come: Delivered under the Similitude of a Dream Wherein Is Discovered, the Manner of His Setting Out, His Dangerous Journey, and Safe Arrival at the Desired Country* [1678], 2ND ed., rev. ed., ed. James Blanton Wharey (Oxford: Clarendon Press, 1960), 15.
11 Di Palma, *Wasteland*, 125
12 Di Palma, *Wasteland*, 95.
13 Diane Jones Allen "Living Freedom Through the Maroon Landscape," *Places Journal*, September 2022, https://doi.org/10.22269/220922.

between what was and was not to be protected.[15] His expansive photograph *Yosemite Valley, California* (1865) and other works made several years earlier coincided with the beginnings of the Civil War and contrasted with the landscapes of devastation in the South that were circulating in newspapers. Watkins's images tied the West to Northern cultural traditions through imagery focused on the beauty and spectacle of nature.

The direct connection between photography and land preservation continued well into the twentieth century with, in particular, the work of Ansel Adams in Kings Canyon and George Masa in the Great Smoky Mountains. These images not only redefined what spaces were designated as beautiful, but also reconsidered what — and who — was worthy of safeguarding based on aesthetics and cultural values. To view these works now also requires an understanding of the exclusionary practices our valued park system was founded on and continues to perpetuate. The histories they tell and visualize create the assumption that these lands were "empty" or "untouched" prior to their designation as national parks, despite centuries of Indigenous habitation. Together, they rewrite the history of occupation of the land as part of our country's nation-building project — one in which these same parks remained segregated up until 1964.

At the same time that these representations of landscapes like Yosemite and other national parks perpetuated the American ideals of natural beauty, spaces that did not incorporate the same physical attributes and aesthetics were and continued to be underrepresented in the canon of American art.

14 Novak further states that "photography first entered the western terrains when the powerful esthetic system that had sustained the vision of nature was at its apogee in the mid 1860s. Through the seventies and eighties, while that system was collapsing, the photographers roamed the western territories with remarkable results; their work sometimes triumphantly sustained the conventions of the picturesque, at other times escaped them, as extraordinary data pushed into their pictures with pragmatic authority. So a major function of the artist was taken over by the photographer — the provider of authentic evidence. Armed with the machine, their work stamped with its imprimatur, the artist-photographers confirmed the existence of the fantastic and of themselves as the agents of its transfer. The truth of the photographic image was one of its most durable conventions and that truth was accepted as an article of faith by the photographers themselves and by their public." Barbara Novak, *Nature and Culture* (Oxford: Oxford University Press, 1980), 153.

15 Jarrod Hore, *Visions of Nature: How Landscape Photography Shaped Settler Colonialism* (Oakland: University of California Press, 2022), 42.

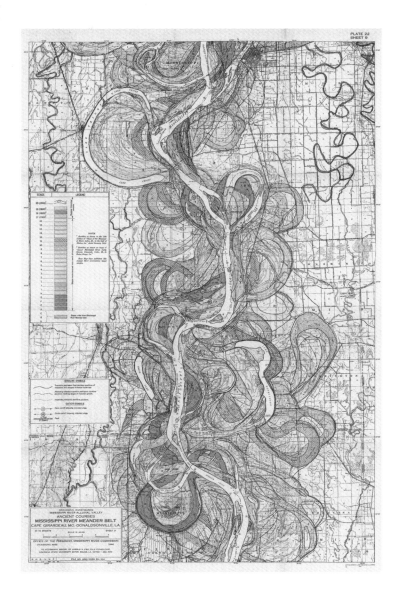

Mississippi River Meander Map, plate 22, sheet 9, Harold Fisk, 1944.
Courtesy of the US Army Corps of Engineers.

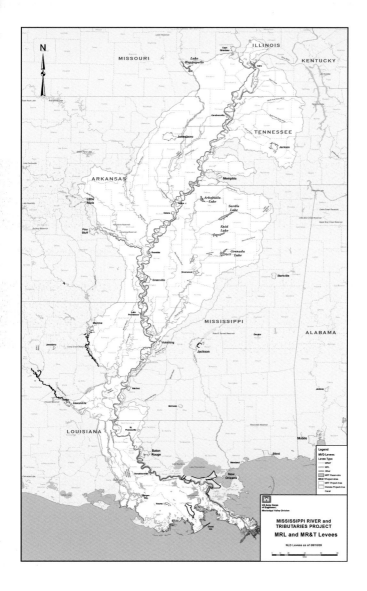

Map of Mississippi River levees from Cape Girardeau, Missouri, to Venice, Louisiana, 2009. Courtesy of US Army Corps of Engineers, Mississippi Valley Division.

IV.

 Despite the Louisiana wetlands not receiving recognition at the scale of our natural parks, it remains one of the most diverse ecosystems in the world. And its lack of representation in the American art canon has not precluded it as a site of interest and management by the United States. On the contrary, it has become a site of extreme opportunity, extraction, and exploitation, and various forms of visual intervention, like the mapping of infrastructure and natural resources, have played a large role in facilitating these actions. Investigating these concerns requires sifting through the many layers of Louisiana's current environmental crisis, an emergency that is not just ecological but social in nature. While this project does not aim to provide an exhaustive history of this crisis, I want to meditate on several key infrastructural interventions that have attempted to constrain the presence and flow of water in South Louisiana.

 South Louisiana was formed by the Mississippi River, a fluvial delta that is comprised of sediment carried down from thirty-one states and two Canadian provinces. In the delta's formation some 7,000 years ago, plant communities began to develop as sediment piled under water, trapping more sediment and eventually accumulating into land. With each section of land – called a delta lobe – amassed, the Mississippi River's path to the Gulf of Mexico became longer and more attenuated, unable to meet the ocean. As a response, the river would then change course, abandoning the older lobes to cut shorter routes to the Gulf. New lobes formed with the river's alternate route, building up new land for flora to take hold. This constant ebb and flow is famously depicted by Harold Fisk, a cartographer and geologist for the US Army Corps of Engineers, in his *Meander Maps of the Mississippi River* (1944), in which the river's fluctuations through space and time are represented with an array of captivating colors.

 The original inhabitants of the land that New Orleans sits on were the Chitimacha, with the Atakapa, Caddo, Choctaw, Houma, Natchez, and Tunica inhabiting other areas throughout what is now Louisiana. Much like the river's own wanderings, these tribes traditionally traveled among seasonal villages for strategic and agricultural advantages of the land. However, many were eventually pushed ever closer to the coast in waves spurred by European colonialism, United States expansion, and various industries including logging, fur trading, and oil and natural gas extraction.[16]

By the time of European colonization, the Mississippi River Delta plain stretched 7,000 square miles, making it one of the largest river deltas in the world. As commerce grew after the Louisiana Purchase and into the early nineteenth century, the need to preserve trade routes became critical for the continued development of the southern colonies, especially as the river delta itself was prone to fits of rebellion, like flooding, against such activities.

In 1849, Congress passed the Swamp Land Act, transferring nearly ten million acres of federal wetlands to Louisiana. It was property the US had acquired with the Louisiana Purchase, but for which no "use" had been found due to the perceived inferiority of the swamps because of their inability to be traditionally cultivated. The grant was meant to encourage the state to levee and drain the wetlands – to "reclaim" them, to use the language of the bill, as if in some imagined past the marshland had been usurped from its rightful, productive purposes. Louisiana could sell off the timber from the marshes or try to make it fit for agriculture, setting the stage for one of the largest environmental crises in our country's history.

The river's "unruliness" prompted further cause for federal intervention in the years to come. After the Mississippi River Flood of 1927, the most destructive river flood in US history, with 23,000 square miles of land submerged, hundreds of thousands of people displaced, and over 200 people dead, the government attempted to control water through a series of laws promoting flood protection infrastructure. The Flood Control Acts of 1928 and 1936 authorized the US Army Corps of Engineers to construct thousands of miles of levees, dikes, and dams – structures that were monumental in shaping the landscape throughout the river's watershed. Engineers began to lock the river in place, even though it is the delta's very nature to exist in a state of constant flux.

The physical manipulation of the fluvial environment also had lasting social impacts. During the 1927 flood, Plaquemines and St. Bernard Parishes, which were located downriver from New Orleans, were sacrificed in order to relieve pressure from the levees further upriver. In a decision heavily influenced by bankers and other business leaders of New Orleans, the governor called for the levees to be dynamited. The parishes were flooded, perpetuating the concept of a buffer zone, where the displacement of people, their

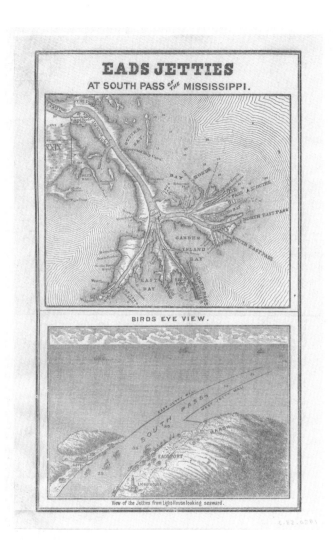

Eads Jetties at South Pass of the Mississippi, wood engraving of map and bird's-eye view, 1890. Courtesy of the Historic New Orleans Collection, the L. Kemper and Leila Moore Williams Founders Collection, 1950.58.3.

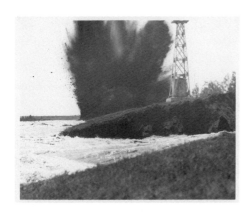

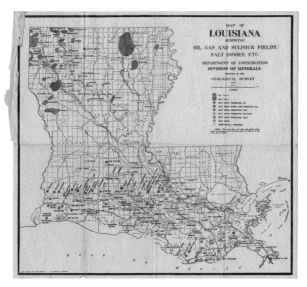

Top: *Caernarvon Crevasse Blast*, 1927. Photograph, 8 × 10 in. Courtesy of the Historic New Orleans Collection, 1974.25.11.63.

Bottom: *Map of Louisiana charting the presence of oil, gas, sulphur fields, salt domes, and the like*, M. B. Stephenson and James H. McGuirt, 1935. Lithograph, 17 1/2 × 19 3/8 in. Courtesy of the Historic New Orleans Collection, 2013.0223.

homes, and their communities was accepted for the sake of upholding infrastructure for the benefit of others – a practice that has led to intense distrust of the management and purpose of these infrastructures to this day.

v.

This idea of buffer or sacrificial zones was exacerbated by the proliferation of the oil industry. In 1901, the Spindletop gusher, located about 270 miles west of New Orleans near the Louisiana-Texas border, marked the beginning of oil exploration along the Gulf Coast. Oil companies began further reshaping the Louisiana landscape by dredging canals to transport crude; two major shipping canals were carved out to serve the city of New Orleans: the Industrial Canal, dredged through the Ninth Ward in 1923 to connect Lake Pontchartrain with the Mississippi River, and the Intracoastal Waterway, a federally funded project spanning the Gulf Coast that was linked up with the Industrial Canal in 1933.

These canals, along with countless others created to transport oil and gas, had consequences. The water in coastal Louisiana's wetlands had been fresh or brackish, but the new canals allowed salt water from the Gulf to intrude deep into the marsh, killing the flora that had once thrived there. Meanwhile, as tugboats drilled barges and speedboats brought workers back and forth from oil fields offshore, their waves battered the grasses, increasing the rate of erosion. Narrow canals became wider with water creeping farther north.[17]

In *Louisiana Story*, scenes of drillers working beside Cajun families perpetuate the myth that there are no environmental consequences of fossil fuel extraction. In reality, the industry causes coastlines to erode, health disparities to increase, economic inequality to heighten, and communities to become displaced as land disappears into water. The film, with its award-winning artistry along with other visual material like postcards and billboards, undoubtedly contributed to Standard Oil's successful reach across the region.

16 Molly Reid Cleaver, "Pushed to the Coast by Man, Indigenous People in Southeastern Louisiana Feel Nature's Push Back," *First Draft: Stories From the Historic New Orleans Collection* (blog), *The Historic New Orleans Collection*, October 8, 2021, https://www.hnoc.org/publications/first-draft/pushed-coast-man-indigenous-people-southeastern-louisiana-feel-natures-push.

17 Andy Horowitz, *Katrina: A History, 1915–2015* (Cambridge, MA: Harvard University Press, 2020), 34

There are currently signs along Highway 90 through Lafourche Parish sponsored by Shell; one of them reads "Growing Louisiana Together" with trees being planted in the background. You may pass it on the way to the New Orleans Jazz and Heritage Festival, also presented by Shell. The industry's relationship with media and art continues to tell a story of environmental and cultural stewardship with its pervasive presence. The New Orleans Museum of Art, Ogden Museum of Southern Art, New Orleans Film Festival, and many more of the city's cultural institutions receive support from foundations funded by the oil and gas industry's wealth.

Louisiana has a fifty-year, fifty-billion-dollar Coastal Master Plan, which is intended, as its latest edition states, to "preserve coastal Louisiana's rich culture, ecosystems, and natural resources threatened by ongoing land loss and flood risk."[18] The initiative is made possible, at least in part, by settlement money from the Deepwater Horizon oil spill in 2010 that devastated Louisiana's coastal ecosystems along with local seafood industries.

In the 2023 iteration, and for the first time in the agency's history, the Coastal Protection and Restoration Authority, the governmental body overseeing the plan, added language around moving people and infrastructure proactively before conditions become too dire.

VI.

Since the 1930s, approximately 2,000 square miles of the state's coast has sunk into the Gulf of Mexico, a figure that is well represented in maps and diagrams meant to convey the magnitude of what has already been lost and to project what we will continue to lose. The desire to understand "disaster" at this scale has encouraged a form of visualization that seeks to make legible the complexity of changing landscapes in a compact form. An image-based culture fortifies a singular narrative and resists nuance or the encouragement of meaningful, open-ended discourse. A quick image

18 "2023 Coastal Master Plan," Coastal Protection and Restoration Authority, https://coastal.la.gov/our-plan/2023-coastal-master-plan.

19 See Carolyn Kousky, et al., *A Blueprint for Coastal Adaptation: Uniting Design, Economics, and Policy* (Washington, DC: Island Press, 2021), 58; and Hore, *Visions of Nature*, 41.

20 Mark Monmonier, *Coast Lines: How Mapmakers Frame the World and Chart Environmental Change* (Chicago: University of Chicago Press, 2008), 1.

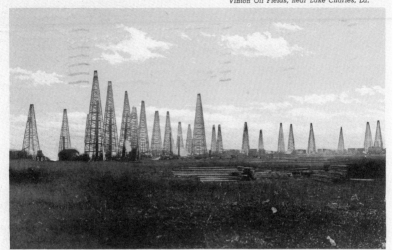
Vinton Oil Fields, near Lake Charles, La.

16802-C-N

A postcard of Vinton Oil Fields near Lake Charles, Louisiana, Shafer News Agency, 1952. Offset lithography, 5 ¹/₂ × 3 ¹/₂ IN. Courtesy of the Historic New Orleans Collection, gift of Alvin Schaut, 2017.0464.4.

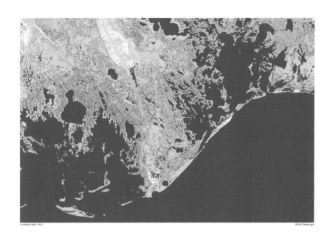

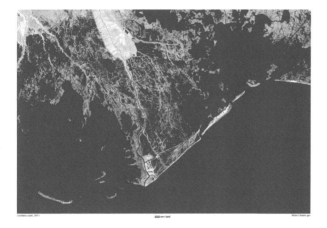

Maps showing land loss in Southern Louisiana by 1932 (top) and 2011 (bottom). Courtesy of the National Oceanic and Atmospheric Administration, Climate.gov, April 5, 2013.

search for "Louisiana land loss" will produce countless maps of various colors and scales that impose a singular and essentializing way of seeing if taken at face value. Reading a single image of disaster as a depiction of climate change dismisses the evidence of communities, of life, of people who still make a home in these places and have always lived on and with the water.

As I am writing this, one of the largest liquefied natural gas (LNG) terminals in North America is being built in Plaquemines Parish. It is directly adjacent to a coastal restoration project that diverts the course of the Mississippi River in order to build new land with its sediment. A map of the state's Coastal Master Plan does not mention information on the new energy terminals such as this one and others being built across the coast whose carbon outputs diminish, if not completely negate, the impact of any attempts at the restoration or preservation of what still remains of Louisiana's coast.

Like painting and photography, mapping processes and policies have inherent biases built into them. And also like photography's documentary role, maps are not just representations, but also instruments for categorizing, delineating, and exploiting territory.[19] In many ways a coast cannot be mapped; it naturally resists the easy form of delineation this representation technique imposes. As cartographer Mark Monmonier shows us, coasts pose physical challenges for mapping, as "the coastline is raised and lowered twice daily by tides and occasionally realigned by storms, which famously shorten the shelf life of nautical charts, on which its representation demands careful measurement and prudent compromise." They also pose a conceptual challenge: "Because the sea provides food, transportation, and recreation, the shoreline is at once a boundary, an attraction, a source of livelihood, and a hazard."[20] It possesses a unique geography – it is a site of exchange of people, things, practices, beliefs – where multiple truths exist at once.

This project challenges reading this visual material as fact and instead embraces the dynamic nature of the coast and of the river. It presents alternative ways of seeing this landscape that blur the borders and boundaries that have been created in favor of upholding and fortifying disaster-oriented narratives.

VII.

I cannot tell you how to read this book, but I can provide answers to the questions that I am asked the most as a starting point.

I am often asked why there are no people in my photographs. If there is no separation between the social and environmental impacts of climate change, why are there no humans in these pictures? How can I speak to the history and culture of a place without people populating the frame?

I am of the school of thought that the built form holds collective memory, that it often has more power to describe how we view the land and each other than portraiture can.[21] And while it is true that ecological and social destruction are inseparable, I have found that the dominant disaster aesthetic that has emerged along with climate change has, in the worst case, incited dissociation by the viewer due to fear. What are the psychological impacts of disaster imagery when they are used as stock images in our twenty-four-hour news cycles?

This book resists that spectacle. Instead it presents a collection of photographs primarily focused on the built environment because I have found that these structures have a power of communicating the juxtaposition of monumentality and permanence in a shifting landscape. Architecture and infrastructure are the manifestation of beliefs and values in physical form. They also assist in communicating how disasters are created, with the pretense that they do not happen in a vacuum.

The photographs collected here span nearly a decade of work chronicling my own adoration for and continued curiosity about South Louisiana and the transient space where land meets water. As a transplant from the previously mentioned Hudson River Valley, my perception and understanding of an iconic American landscape was instilled in me from a young age. I grew up observing the impacts of landscape art as it relates to the preservation and protection of nature as well as the adverse side effects of creating a landscape of consumption based on tourism and leisure.

Many of these photographs were made after returning to a specific area again and again over many years in order to illustrate time through the subtle changes, or lack thereof, in the built form. Some may consider the work banal, and that is with intention, for it forces us to reckon

with the specific elements present in everyday life as they relate to a larger, ongoing crisis. Looking for the stillness in a state of constant change is a human tendency and is also how this project came to be. The photographs I am often drawn to capture moments of quiet that point to something beyond the frame, to that which is bigger than ourselves. Borrowed from a quote by the photographer Robert Adams, whose decades-long career focuses on documenting the devastation of forests in the American West, the title of this book reflects the ephemeral moments of stillness in the storm.[22] There is an eloquent silence of light and beauty, one that holds promise.

In 2022, art historian Anne Wagner gave a lecture at the Whitney Museum of American Art on the practice of land artists Robert Smithson and Nancy Holt, referencing the work of British-Palestinian artist Mona Hatoum in the title of her talk "Measures of Distance." She stated that "space is emotional as well as physical… yet distance is always a matter of viewpoint; it can be courted by an artist rather than imposed; it can be welcomed rather than resisted, with the result that its principal components, time, space, vision, emerge as essential to the work."[23]

21 William Christenberry's career photographing Alabama informs this belief, particularly his typologies of the same building, which illustrate the gradual changes of color and structure, marking the passing of time, and signifying the shift from reality to memory when shown together.

22 "In middle age, I revisited a number of marginal but beautiful landscapes that I had taken for granted when I was a boy. As I walked through them I sometimes asked myself whether in the coming years they would survive overpopulation, corporate capitalism, and new technology. On those days when I was lucky, however, my questions fell away into the quiet and the light." Robert Adams, *Gone? Colorado in the 1980s* exhibition, Fraenkel Gallery, 2010.

23 Anne M. Wagner, "Measures of Distance: Space and Sign in the Work of Nancy Holt and Robert Smithson," Holt/Smithson Foundation lecture, Whitney Museum of Art, December 13, 2022, https://whitney.org/media/54738.

My approach to making photographs over the better part of the last decade has also been influenced by this concept of scale and distance, particularly as they relate to perception. The distance between buildings, between a house and the ground, and between a house and a floodwall communicate our relationship with the earth. In embracing the reality in which no two people see or react to things in the exact same way, I am interested in exploring perception both experientially and ideologically and how this layering of experience challenges the limits of representation in visual material. A photograph is both

analytical and subjective; it is never truly objective.

Photographs in the aftermath of massive storms like Hurricanes Katrina and Ida tend to unfold sweeping, large-scale landscapes of destruction. This type of imagery, often captured by way of aerial and drone photography, combined with maps and data-oriented graphs, dominate the visual database used by the media to illustrate the violence of climate change. What is difficult to capture, however, are the residents' important behavioral changes and emotional connections they have forged with this landscape: the generational ties to the land and those who have and continue to nurture it.

Since I moved to Louisiana in 2014, my understanding of this place has been shaped by the work of chefs, architects, climate activists, shrimpers, coastal engineers, musicians, and so many more who are advocating their own interpretation of preservation through storytelling. Much of my learning has come from the contributors included in these pages. They have helped me see in ways that a still frame can never capture, and their words collected here speak with and across my photographs and with each other. They populate the photographs and animate the many different ways of seeing, being with, and being in a changing landscape. They reach across time, across various sites, across forms and genres to share multiple, yet interconnected histories and reflections on the present. They trace legacies of enslavement, of displacement, of toxicity; stories of the everyday, of picking up the pieces, of resistance; they weave in and out of sorrow and of hope. The stories and photographs, taken together, are necessarily messy and incomplete; they remain unresolved in that they do not collate into a singular reading of a particular place. On the contrary, they make space for the many different worlds in which we live.

In that same spirit, you will find that this project approaches the built environment as a way of seeing the different, potentially parallel futures that exist and various ways of living with risk. At the core of the project is an effort to encourage thinking of this region — and coastal communities around the country — as an interconnected system rather than as separate and expendable landscapes. Whether it is population density or economic output, certain characteristics designate which areas are more worthy of structural protection

24 Robert Adams, *Along Some Rivers: Photographs and Conversations* (New York: Aperture, 2006), 73.

based on the perception of value. In my photographs, I intentionally seek out both direct and indirect evidence of these designed interventions to capture not just how we have normalized unnatural changes in habitat, but also to speculate on what that means for our shared future.

Robert Adams, on finding beauty in the destruction, affirms:

> When I'm photographing in clear-cuts, I know that what has brought me there is a sense of the world coming apart. But after I've been there long enough to get over my shock at the violence, after I've been working an hour or two and am absorbed in the structure of things as they appear in the finder, I'm not thinking only about the disaster. I'm discovering things in sunlight. You can stand in the most hopeless place and if it's in daylight you can experience moments that are right, that are whole.[24]

His words describe a universal experience that we share in which the light and the darkness exist simultaneously.

There is no certainty as to what the next century or even the next fifty years will look like for coastal communities around the world, and I cannot tell you the correct way to see the images collected in this book because there is not one. But at its core this project is dedicated to complicating disaster-oriented narratives and the imagery and imaginations that come with them. It is a book about multiple truths existing at once, about looking at the light and the dark and that which meanders between.

Into the Quiet and the Light

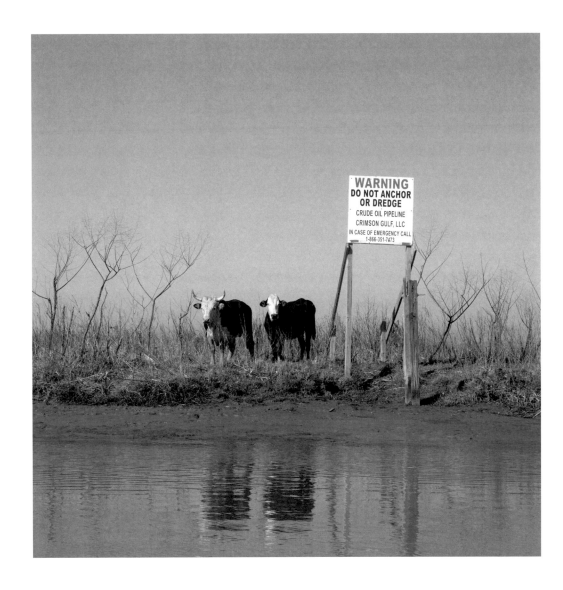

Marsh Cows Near Venice, Plaquemines Parish, 2022

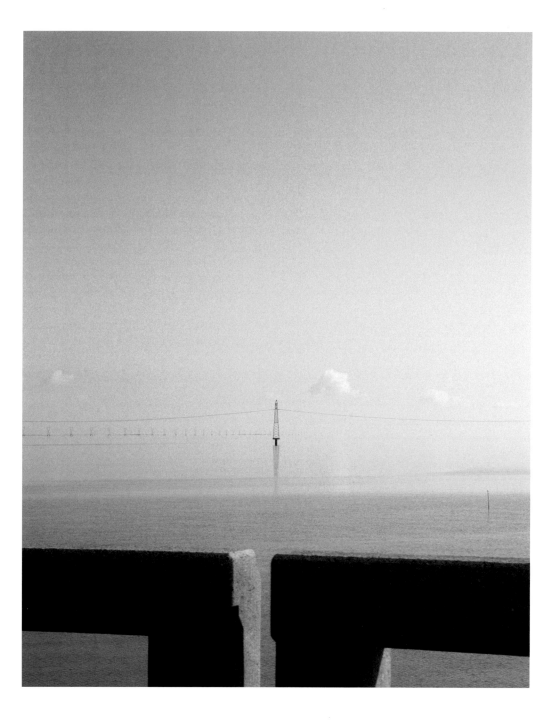

Power Lines over Lake Pontchartrain, 2022

Picturing Emergence, or *Salix nigra*
Kate Orff

 Before the US Army Corps of Engineers built the massive levees we see today, which locked into place the water and sediment that once nourished a healthy delta, the horizon of the lower Mississippi was dynamic and changing. Pulses of sediment from the river would

fan out and layer up over time, pushing and pulling channels, building shallows, and driving cycles of fish, dolphin, shrimp, and bird migration across the delta.

Landscapes are not meant to be fixed. When fresh water from the river swirls together with the salty streams flowing in from the Gulf of Mexico, the horizon responds – mudflats emerge and plant communities flourish and die back, all mirroring shifts in salinity. Tupelos appear as sentinels of freshwater dominance and recede as the river changes course and salinity surges. All the while a matrix of black mangroves expands and contracts along with the shifting sands of Louisiana's outer barrier islands.

Today that dynamism remains stifled. A largely flat monoculture has resulted from decades of sediment starvation, a century-long attempt carried out across space and time to control the river's flow and fix its salinity envelope in service of the petrochemical economy. Once oil was extracted from the crevices and pockets deep below the water's surface – burned, cracked, and exploited in a thousand ways – a landscape of our own making came to dominate the picture. Thick, wild marshes have been cut, dredged and canalized into skeletal patterns, carved into oil and gas leases, and locked into decline by a rigid system of levees separating the river – a mud engine – from the marsh landscapes it once sustained.

A literal/littoral parable of the self-devouring growth of the United States economy and our relationship to water, land, and the in-between, the state of Louisiana exchanged short-term corporate profits for long-term coastal degradation. It has shifted dramatically away from water-based economies, and seen the plummeting of bird, fish, and shellfish populations. It has witnessed an erosion of culture and community, an erosion and submersion of the land itself.

But fresh changes are on the horizon – seeds of hope that signal a river engine on its way back into the frame. The river has burst through the levee's walls in a few places, notably on the east bank of the Mississippi at Neptune Pass, where what was once a narrow canal is now teeming with life and growth. Sediment is flowing into Quarantine Bay, where a new sub-delta is emerging, reversing the pattern of land loss in what is both a happy accident and a promise for the possibility of a future beyond extraction. Here we can see sprouts of black willow (*Salix nigra*) on

the horizon, a pioneer emerging delta species and an indicator of a healthy, actively building delta. They are signposts of the river's persistence and of a dynamic community in formation.

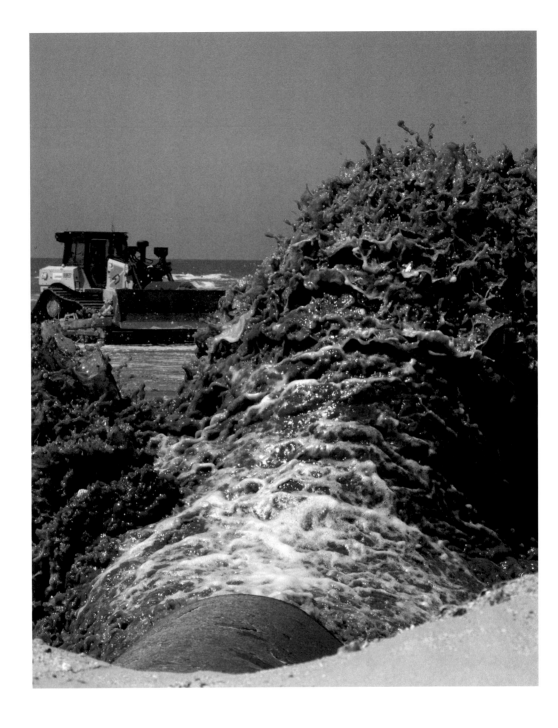

Sand Pipeline, Trinity Island Restoration Project, 2021

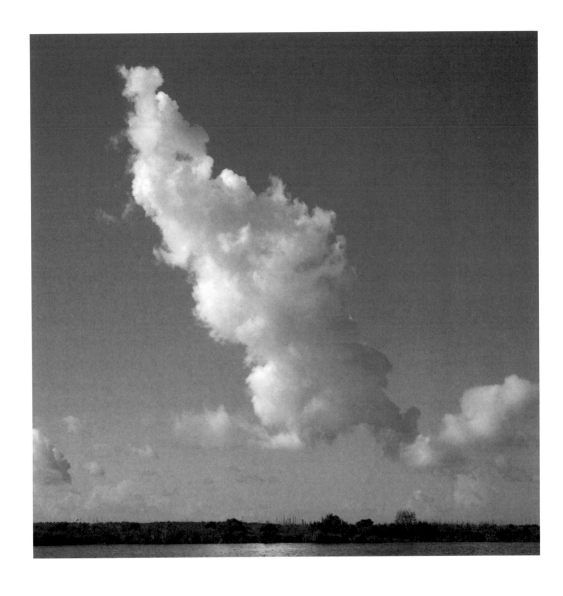

Chalmette Refinery from the Mississippi River-Gulf Outlet, 2023

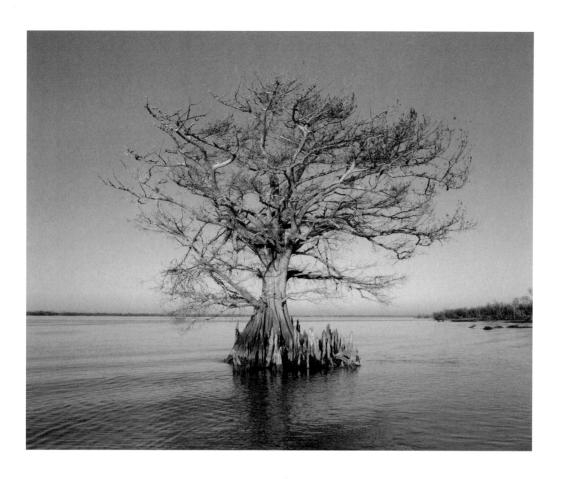

The Mississippi River South of Port Sulphur, 2022

Out of Touch and Over the Horizon
Richie Blink

 Sitting down to think about this has been hard. Between trips to the Delta, boat maintenance, and a little time to relax, tearing into how I feel about my community's eventual permanent inundation and how humanity is – or isn't – leaning into climate change hasn't exactly risen to the top of my list. It's not that I don't want to think about it. On the contrary, adaptation to climate change is something that I spend most days observing and showing others. It's not all that hard to sift through the past and consider how we could have avoided the pitfalls of unchecked development experienced by my community and the surrounding ecosystems that support(ed) it. All that said, this piece is being sent to the editors at the last possible moment. Could they have expected a different approach from someone living on the front lines, someone who is prepared to step aside only at the last possible moment?
 The mouth of the Mississippi River is all but forgotten, and at the same time

it's the focus of countless anthropologists, city planners, organizers, and engineers. For nearly 300 years, since European arrival to the Americas, we've tried to develop this watery landscape with an eye toward economic certainty. But now that we've nearly exhausted all it has to offer, experts say that nature is wresting back control, that no amount of money can stop the rising tides.[1] In a case of life imitating art, unfolding before us in real time is the plot of *Beasts of the Southern Wild*, a 2012 film set on a mythical island imagined to be outside the levee system, which happens to be just offshore from my own town, Empire, along the Mississippi River, south of New Orleans. Spoiler: the movie doesn't end well for people inside the levees.

 We often envision what a decent standard of living should be – most in the United States would assume that it involves *dry land*. The folks that are making policy decisions that contribute to the cultural and ecological collapse of the coast are playing into those same standards and biases. For years, I was mad at them for that, for insisting that residents retreat from coastal areas. I just *wish* I could have convinced them that for communities like mine, people would still be working here for a time, certainly through any forthcoming inundations. If only the conversation centered on buying time instead of on getting everyone out. There are many biases that need to be overcome when dealing with changes along the coast or how inland communities will choose to deal with adaptation to their climate battle. Thankfully, some planners are now thinking across multiple timescales. Can intertwined short, medium, and long-term visions for imperiled communities transcend beyond academic exercises to actionable policy before it's too late for the most vulnerable? I hope so.

 Humans have occupied this region for thousands of years by building earthen mounds. Cultures along the Amazon and Mekong Rivers and here in North America on the Mississippi have been thriving around water for a long time. But under colonialism, planners have had difficulty imagining how these watery landscapes can be a complement to the United States' economic system. The way our current society here in the Delta is being rolled up and packed away is actually counter to these dominant notions of progress. It's like a game of monopoly in reverse. Cable TV and gas service were the first to go after Hurricane Katrina in 2005. Nearly two-thirds of the population took the chance to bow out then. I fear that the loss of municipal water service may be only a

couple of decades out. The latest blow, however, wasn't from the private sector or the local government, but rather from the feds.

Risk Rating 2.0 is a FEMA policy that makes it effectively impossible for people with an average income to live along the US coast, and it will soon be tested in the Louisiana parish of Plaquemines.[2] Any new construction must adhere to a new base flood elevation, which at my house is a dizzying 19 feet above the ground. The policy doesn't just cover new construction, however, it even goes as far as to include trailer permits. Cleverly written, and insultingly enough for those that choose to live out the rest of their lives in these imperiled places, there are no grandfather clauses if one files a permit to restore a home in the event it sustains more than 51 percent damage. FEMA-appointed inspectors will be given the task of determining that level of damage after the next tropical landfall. Surely no biases will seep into that process. Beyond the material and economic effects, this policy threatens the emotional and social well-being of coastal communities. In my former role as a parish councilmember, I fielded a myriad of complaints, including domestic abuse, exacerbated by the new policy.

Looking forward, we will need to brush aside the limits on our imagination if we are to continue making a home of these watery landscapes. Floating infrastructure, well-built dwellings of a modest size, and a fair permitting process designed to at least *consider* affordable adaptation are key to continued economic activity here. Creative mortgage products that allow for home elevations could help keep areas livable for the foreseeable future. The ideas and innovation necessary to adapt are going to be found within at-risk communities. It's up to the policymakers to hear and help and to respect first and foremost community members' desire and right to keep living along the coast. Anything less and I'd have to start buying into the conspiracies my neighbors trade around of the intentional emptying of the coast to make way for industrial activity, a natural buffer, or some combination of both.

Humans have lived here with water for thousands of years. There is incredible value in having folks at the front lines adapt to meet the challenges of the Anthropocene, with oversight that is not out of touch or over the horizon. Still, as bad as it may get here, the communities that receive climate refugees are not ready for scores of my neighbors.

1 The earliest European attempts to occupy
 Bulbancha, which later became the city of
 New Orleans, had city engineers building
 levees to prevent flooding by the Mississippi
 River. If the Europeans used Indigenous
 techniques of mound building instead
 of fortifying an ever-increasing built
 environment, humans could have lived
 within the bounds of nature. Extraction was
 easier with levees than without them. The
 landscape could be flooded for up to ten
 months a year, which was counter to a
 capitalistic vision where goods must move
 in predictable ways.
 Levee building and the pumping it
 requires spread around Louisiana and now
 much of the Mississippi River is leveed in
 some way. This all leads to cascading and
 intertwined human and environmental
 issues. I could spend all day diving into
 them. Many of these issues could be solved
 by giving natural ecologies a little room,
 by humans adapting better to their natural
 surroundings. We're experiencing 300 years
 of siloed interests thrown into a blender with
 the ecological world getting the raw end
 of the deal. We're at the point where that
 economic certainty that we humans love so
 much is starting to become harder to find.
2 See "NFIP's Pricing Approach State
 Profiles," FEMA.gov, accessed January 22,
 2024, https://www.fema.gov/flood-
 insurance/risk-rating/profiles.

The River, the Giver
Jessi Parfait

 The coast of Louisiana owes its existence and the abundance it provides to the Mississippi River. At one time, the River flowed freely, slithering across the coastal landscape and depositing sediment, eventually building the entire delta and the land my ancestors, the Houma, would come to inhabit thousands of years ago. We have been here since time immemorial, using what the landscape has provided as medicine and sustenance, as materials to build homes and boats to navigate its waters. For thousands of years, it was enough. But when colonization began, nothing these lands could provide would ever be enough again.

 Recognizing the importance of the River as a gateway to the rest of what would later be called America, early colonizers raced to find its mouth in order to claim the entire Mississippi River basin. In 1682, the French explorer René-Robert Cavelier, Sieur de La Salle found the mouth of the Mississippi River and claimed the entire territory for France, naming it La Louisiane,

thus beginning Louisiana's long history and continued existence as an extractive colony. Logging of our virgin cypress trees began in the early days of French settlement but experienced a boom in the late 1800s. That boom, though, was all but over by 1925 – in less than fifty years, trees that were well over a thousand years old were felled so thoroughly across the state that eventually, only a single, lone tree remained.[1] Logging destroyed over 1.6 million acres of cypress. Exported across the country, the trees were used for everything from new homes to boxes used to carry Spanish moss. There is no depth to the greed.

While the River is a creator, it was exploited to carry enslaved people from Africa to be sold in New Orleans, which became the largest slave market in the country. The same River that made life here possible was also used to ship the cotton and sugarcane produced by the plantations that littered its banks. When slavery was abolished in 1865, many newly emancipated peoples transformed the slave quarters of these plantations into their own communities, or "freetowns," along the River. Later, however, the large tracts of agricultural land from former plantations became the grounds for one of the country's largest petrochemical build-outs. By 1980, freetowns were suffering from some of the highest levels of air toxicity in the United States. More than 200 petrochemical facilities now line the River, forming what residents call "Cancer Alley," a term first used by residents in the late 1980s when they began noticing the high rates of cancer on a single street. The term has since evolved and residents now refer to the area as "Death Alley" as industry continues to expand. The Environmental Protection Agency has found that one parish in Death Alley, St. John the Baptist, has continuously had one of the highest cancer risks in the past decade.[2]

The expansion of polluting facilities continues downriver. It continues despite community opposition, despite the destructive forces of impending hurricanes like Katrina, and despite the coastal land loss that poses a threat to every coastal resident, regardless of means or background. The colonization of the River, its lands, and its people did not end with the Declaration of Independence or the Emancipation Proclamation. Rather, its banks and waters continue to be populated with foreign companies funded by investors, all of whom make record profits off the backs of Louisiana citizens, sacrificing our health, safety, and livelihoods in the process. Today, our River transports all manner of products

across the world. And yet, we are one of the poorest and least educated states in the country.

Once a blessing from the Creator that is as beautiful as it is nourishing – not just for my people, but for every tribe upstream that has made a home along its banks – the River is now littered with petrochemical build-out. Now, it carries agricultural runoff from farms upstream that cause a hypoxic dead zone in the Gulf of Mexico every year. Now, it is full of signs that warn of unseen danger.

And yet, I still love it. I love it for all that it has created for generations of my people, for the beautiful sunsets I am lucky to witness across its waters, for the black-berries I pick near its banks, for the sediment it delivers to build land in the few places it's allowed to, for the habitat it provides to all the species I can see, like birds and other fauna, and even those I can't beneath its surface. Most of all, I love it for the way it continues to inspire me to fight for my home. Because while so many others see the River as nothing more than a means of profit, I see and feel its unconditional generosity, always.

1 Donald W. Davis, *Washed Away?: The Invisible Peoples of Louisiana's Wetlands*, (Lafayette, LA: University of Louisiana at Lafayette Press, 2010).

2 "Waiting to Die:" Toxic Emissions and Disease Near the Louisiana Denka / DuPont Plant, University Network for Human Rights (July 2019), 5, https://www.epa.gov/sites/default/files/2019-12/documents/waiting_to_die_final.pdf.

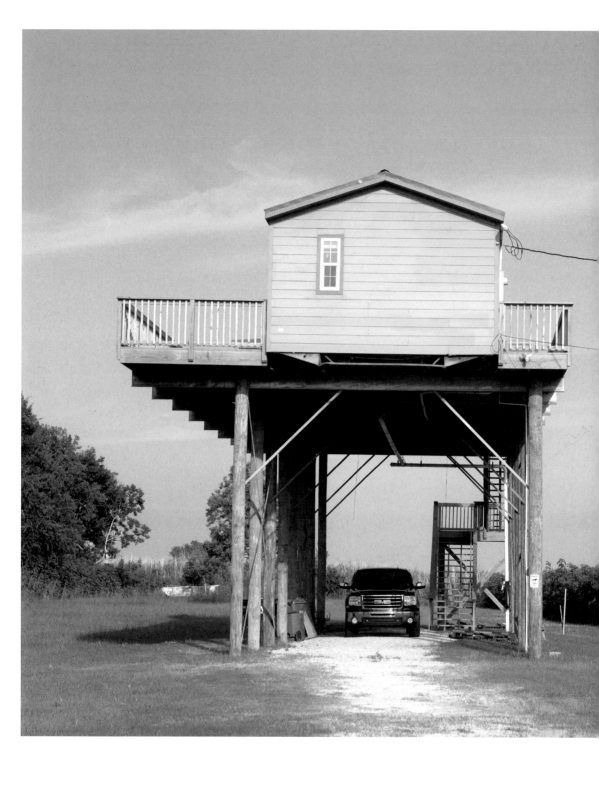

Raised House in Delacroix, St. Bernard Parish, 2022

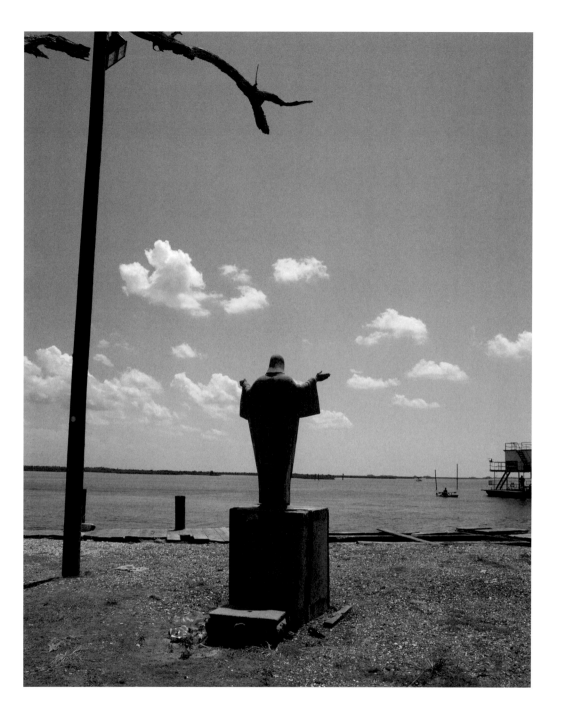

Pointe Aux Chene Marina, Terrebonne Parish, 2018

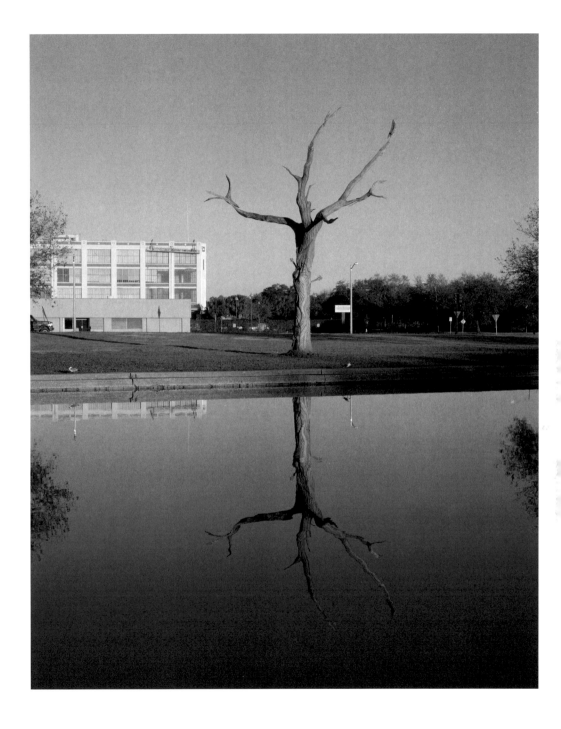

Tree on Bayou St. John, New Orleans, 2020

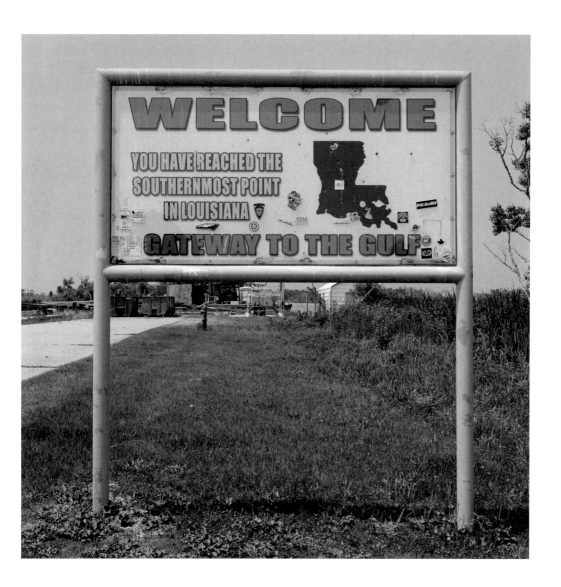

Sign in Venice, Plaquemines Parish, 2022

Life at the End of the Road
T. Mayheart Dardar

The hunters initially thought their dogs had picked up the track of a fugitive slave… As the hunters closed in, however, they discovered that the fugitive was in fact Native American – and therefore not worth sparing. They raised their rifles, took aim, and shot. As they approached the wounded man, his identity became clearer. He was about nineteen years old and appeared to be a Creek villager, who must have fled across south Georgia in a desperate attempt to find refuge in the Florida Panhandle. One

hunter drew a knife, pulled the man's hair taut, and cut off his scalp.

— Claudio Saunt, *Unworthy Republic* [1]

Such was the atmosphere and threat to the Indigenous peoples of the American Southeast in the 1830s. The Jacksonian Age had dawned and the growing agricultural empire viewed with avarice the vast undeveloped acres of Native land that had withstood, by that time, centuries of colonial exploration and expansion.

The majority of the white populations on the frontier advocated continued wars of extermination to solve the "Indian problem," whereas many of those removed from the frontier advocated a more humane solution that would give the United States unfettered access to the rich soils beneath Native nations by moving their populations to some marginal territory deemed of little value to national ambition.

While many social activists and Northern politicians fought and nearly defeated Andrew Jackson's legislative effort, it eventually passed. The Indian Removal Act (officially "an Act to provide for the exchange of lands with the Indians residing in any of the states or territories, and for their removal west of the river Mississippi") was signed into law May 28, 1830, and became the mechanism by which the majority of the Indigenous peoples east of the Mississippi River were expelled from their lands and pushed to the margins of the region. [2]

That push inevitably came for the Houma Indian community. Since the turn of the nineteenth century, just prior to the Louisiana Purchase, a band of Houmas had lived at Pointe Ouiski, a village on the northeast edge of the modern town that bears their name. Concurrent with the naming of the town after the local tribe in 1834 was an intense effort to force that same Houma community to abandon their lands.

A failed attempt to gain federal recognition of their land rights in 1817 had left the Houma nation with few options. Tribal leaders had individual claims to land both "down the bayou" from the city and on ancestral land in central Louisiana near the town of Pointe Coupee. Sometime after 1836, with Indian removal in full force across the South, the northern option became too risky. They abandoned

Pointe Ouiski after the home of Chief Rosalie Courteau was razed by townspeople, relocating to their lower bayou lands beyond the reach of the expanding local government.

Here in the swamps and marshlands at the edges of the Gulf of Mexico, the Houma peoples have survived as an Indigenous nation into the modern age. As the decades progressed, they have interacted with poor white and African American communities who have also found their survival and subsistence at the margins – at the end of the road. Colonization and imperialism, which first came for the Indigenous population, have only continued to consume other resources and peoples in the region, leaving a variety of multiethnic at-risk settlements in its wake.

Into the twentieth century, Houma settlements have spread across six parishes along Louisiana's southern coast from the Atchafalaya Basin to the mouth of the Mississippi River. Wedged between the growing population centers and the creeping waters of the gulf at the ends of the road, the Houma settlements have come to be on the front lines of the effects of coastal erosion and climate change.

I grew up in one of the smaller Houma villages, below the town of Venice and just north of the Mississippi River Delta. If you take Louisiana Highway 23 to the end of the road, a few miles beyond the end of the road sign, there is a small body of water called Spanish Pass. In the early 1960s, there were a few wood-framed houses and mobile homes that formed our small community on its banks.

My dad was a commercial fisherman and a trapper, and I spent those early formative years at his side. On our little Lafitte skiff, trawling the waters of the delta and roaming the marshes running trap lines, I learned what had become of the traditional Houma lifeway since my great-grandfathers' time. There, on the margins, in that liminal zone between the salt water of the gulf and the fresh water of the river, the foundation of my life was laid.

Today, half a century later, that community and many others are gone. While a good amount of the larger Houma settlements have survived, many of the smaller ones like Spanish Pass are just a memory. As the years roll on, the effects of coastal erosion and climate change continue to compound the threat to all of those at the end of the road. And as the threat grows, the margins expand and

the forces of environmental and societal destruction creep past the borderlands. They drive into the heart of the empire itself, edging ever closer to those of much more privilege, toward those that think themselves safe and sound.

1 Claudio Saunt, *Unworthy Republic: The Dispossession of Native Americans and the Road to Indian Territory* (New York: W. W. Norton & Company, 2020), 231.
2 "Indian Removal Act (1830)," National Constitution Center, accessed January 22, 2024, https://constitutioncenter.org/the-constitution/historic-document-library/detail/indian-removal-act-1830.

Radiator Rice
Amy Francis Stelly

My one and only ride down to Venice, Louisiana, was a memorable one. We ended up stuck on the road, which I'll blame on blind faith and the idealism of youth.

It all started in the early '80s when a friend, Chef Amina DaDa, asked me and my husband, Philip, to drive her from New Orleans to Venice. She needed to catch a boat destined for the oil rigs. Amina had been hired to cook for the crew on one of the rigs – her latest gig. She had been a restaurateur, but the overhead proved too high for her tiny operation.

We met Amina in the French Quarter

when it was truly Bohemia. My cousin Thomas lived across the street from her restaurant, the I&I. One day he began telling me and Philip about a chef who had opened the restaurant across the street. He said she was "our kind of person" – a vegetarian chef.

"I told her about you," he said. "You should go and meet her." That was music to my ears. I had just begun to explore vegetarian cooking, and I needed a mentor.

The I&I was quietly tucked away behind a corner bar. You would miss it if you didn't know it was there. We walked in and were greeted with a big smile. Chef DaDa looked gratefully to the heavens and said, "Thank you, Jah! You sent them to me." At that point, I knew we were in trouble.

One of the coolest things about Amina was that she owned a 1965 Falcon. It was shiny and black with a red and white interior. We loved that car. When she asked us to drive her down to Venice, we jumped at the chance. It meant we would get to keep the car for as long as she was offshore – a true blessing since our only means of transportation were two old bikes.

While on the road to Venice, the landscape seemed to rise up and envelop us. In my mind's eye, Plaquemines Parish sloped downward as we got closer to the Gulf of Mexico. We seemed to be driving into the water. It was like driving down a giant boat ramp. I was in awe.

About an hour into the trip, the car started running hot and emitting billowy clouds of white smoke. A leaking radiator left us stranded on the highway somewhere in Plaquemines Parish. All we could do was make the hike back to a country store we'd passed a mile back.

Now, the Falcon had had a few problems, but we figured we could get to Venice and back before anything major happened. None of us knew anything about auto mechanics, but Amina had heard that you could stop radiator leaks with rice. The rice would expand in the radiator fluid, find the leak, and stop it until appropriate fixes could be made. It was worth a try. She bought a pound of rice, poured all of it into the radiator, turned on the ignition, and the Falcon started up. We were on our way! Then suddenly, only a few miles later, the car rolled to a halt. We were crestfallen. The fix hadn't worked, and we were still a long way away.

We got out of the car, opened the hood, and carefully unscrewed the hot radiator cap. Lo and behold, the rice had cooked! We had a radiator full of perfectly cooked, white rice. Amina laughed and smiled and said she could not have cooked a better pot herself, apart from the smell of radiator fluid. Other than that, the rice was fine, but the car wasn't and neither were we. We were stuck, and the only thing we could see were the giant white tanks that dotted the industrial properties along the highway. Our only hope was that someone would come along and rescue us.

We waited awhile, and finally two trucks passed – one heading south and the other heading north. Our prayers had been answered. The truck heading south stopped first and the driver asked if we needed help. Luckily, he was also going to Venice. He was headed to the mouth of the Mississippi River to catch a boat going offshore. He offered Amina a ride, and she jumped into the truck. I was a little concerned about her riding alone with a man we didn't know, but I realized she had no choice; she had to board that boat. The saving grace was that she knew how to fight. She was from Hollygrove, one of the toughest neighborhoods in New Orleans. Chances are she would best him before he bested her, if it came to that. They took off, and she made it to Venice safe and sound.

The driver heading north stopped next. He slowed down to ask me and Philip why in the world we were stuck on a highway deep in "the parish." We told him the story, and he shook his head, laughed, and told us we put too much rice in the car. We needed less than a small handful. He opened the door and invited us into the truck – as luck would have it, he was an engineer who was on his way to New Orleans. As we climbed into his truck, I thanked God that we didn't have to walk all the way home.

A few weeks later, Amina came back, and the Falcon was returned to its beloved home in New Orleans. Not long after, our dear friend closed the chapter on riding to Venice to roughneck in the Gulf of Mexico.

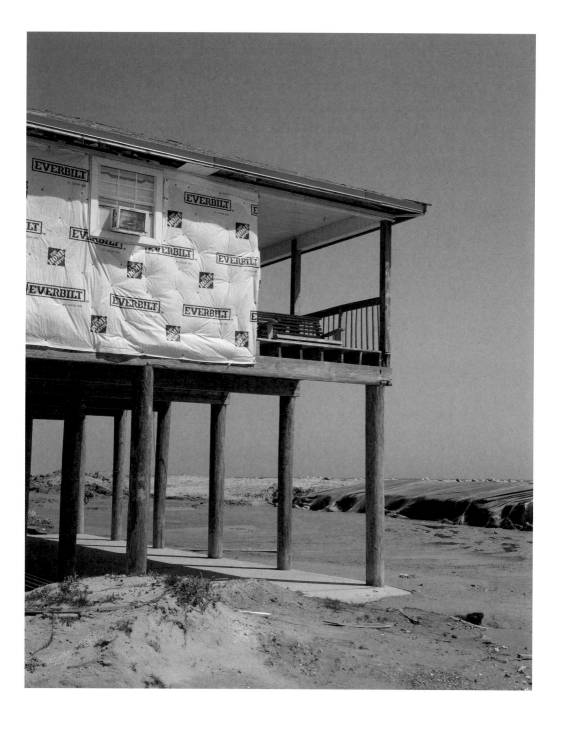

Burrito Levee and Construction on Grand Isle, 2022

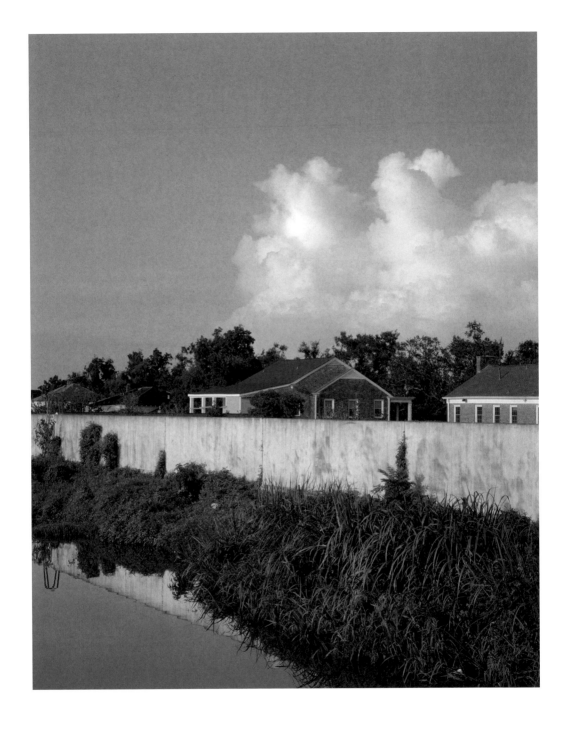

London Avenue Canal, New Orleans, 2021

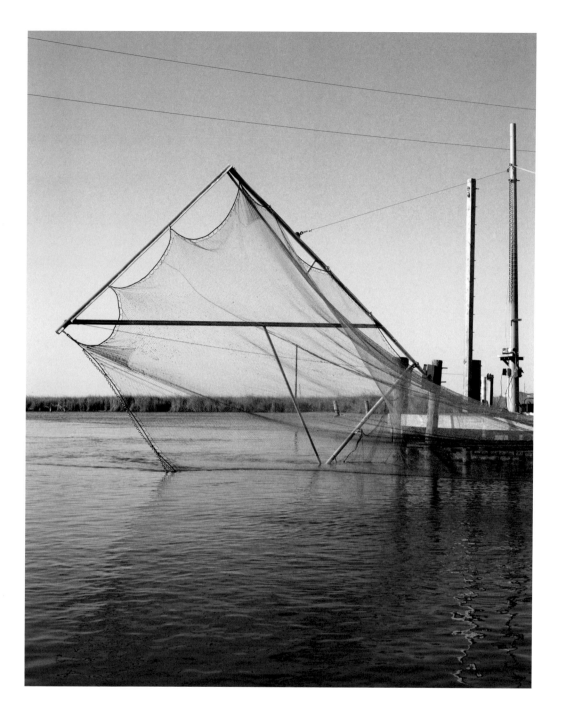

Shrimp Nets Near Grand Bayou Village, 2021

Chạo tôm
Nini Nguyen

Chạo tôm is a dish normally served at Vietnamese weddings. It can be deep fried but I prefer it to be grilled. This recipe is something I envision Vietnamese immigrants in the 1970s making, with the excitement of having access to these ingredients that reminded them so much of home.

Vietnamese people have been the backbone of the fishing industry along the Gulf Coast since the mid-1970s, after the Vietnam War. Large fishing boats greet the docks in the early mornings with tons of fresh seafood, with shrimp being the main source of income for those in the fishing industry. South Louisiana resembles Vietnam in so many ways, including its French influence — Vietnam was colonized by France for almost a hundred years. But the hot climate, laid-back culture, and similar foods like beignets and catfish are what I imagine makes it truly comforting for so many Vietnamese people.

The sugarcane crop also has deep ecological, cultural, and social roots and continues to grow in both Louisiana and Vietnam. You can find sugarcane juice being sold on the streets almost anywhere in Vietnam. Not an endemic species in Louisiana, sugarcane was cultivated by enslaved peoples through the brutal system of forced labor on plantations. Despite the historical and ongoing injustices generated by the sugarcane industry, sugarcane is now farmed alongside rice and crawfish in southwest Louisiana.[1] Remaining cognizant of these complex, multidirectional histories is critical to how we care for our lands, waters, and each other.

1 For more on the history of enslavement in Louisiana and the contemporary injustices related to sugarcane production, see Khalil Gibran Muhammad, "The Sugar That Saturates the American Diet Has a Barbaric History as the 'White Gold' That Fueled Slavery," *New York Times*, August 14, 2019, https://www.nytimes.com/interactive/2019/08/14/magazine/sugar-slave-trade-slavery.html.

Serves four to six people as a snack or appetizer; makes about twelve sticks.

Ingredients

 1 whole sugarcane or 1 can sugarcane
 1 LB. shrimp (peeled and deveined)
 1 egg white
 2 oz. ground pork fat
 2 cloves garlic
 1 diced shallot
 2 TBSP. cornstarch
 3/4 TSP. baking powder
 2 TSP. fish sauce
 1/2 TSP. salt
 1 TSP. sugar
 1 pinch black pepper

Method

1. If using fresh sugarcane, remove the outer layer and cut sugarcane into half-inch-thick sticks that are about three to four inches long. Set aside.
2. Roughly chop half of the shrimp into small chunks (quarter-inch pieces) and set aside.
3. Combine the rest of the ingredients into a food processor and blend into a smooth paste. Be sure not to let the mixture get too warm from the food processor. Pulse if needed.
4. Mix the shrimp paste with the chopped shrimp until incorporated.
5. Wrap approximately 1/4 cup of the shrimp mixture around each sugarcane stick.
6. In a steamer basket over boiling water, steam the shrimp-covered sugarcane until firm and cooked through. This should take about four minutes. Place on the side to cool.
7. Brush with oil.
8. Finish cooking on the grill, turning each stick frequently until evenly golden on the edges and warm all the way through. This process should take about six to eight minutes.
9. Alternatively, you can place them on a sheet pan and cook under the broiler for approximately four minutes on each side.

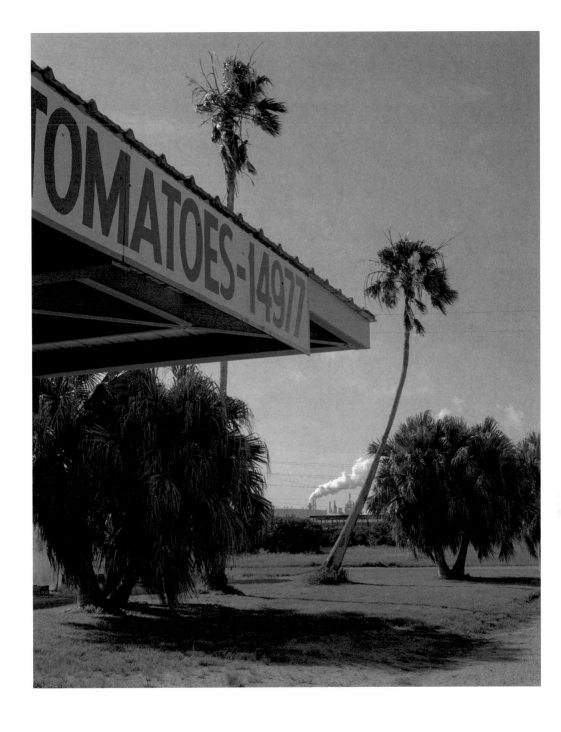

Fruit Stand and Refinery, Route 23 Near Ironton, Plaquemines Parish, 2021

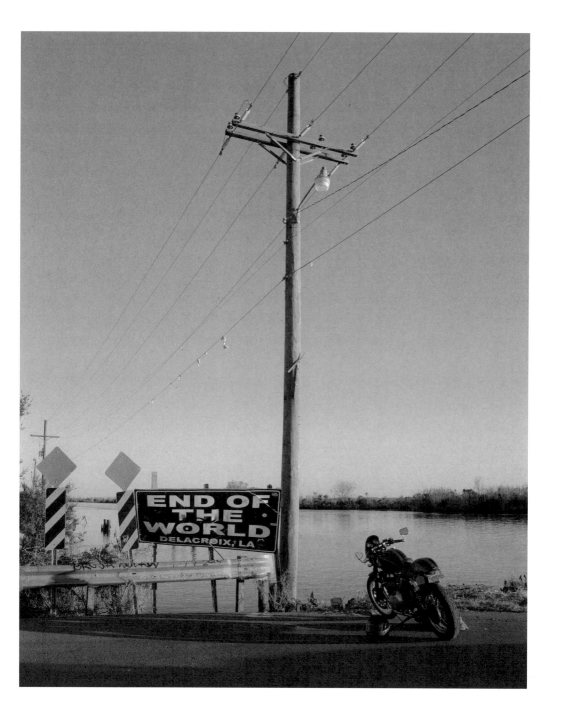

Sign in Delacroix, St. Bernard Parish, 2020

Lake Maurepas Near Akers, 2022

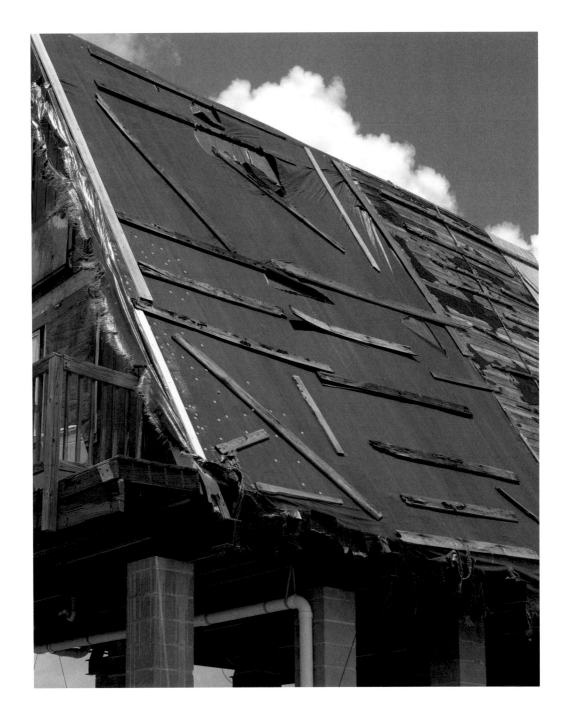

Tarping after Hurricane Ida, Cocodrie, 2022

Industrial Canal Levee, Lower Ninth Ward, New Orleans, 2019

Nurturing the Next Generation Ravaged by Climate Change
Arthur Johnson

While the levee was constructed by the US Army Corps of Engineers after Hurricane Katrina, a platform overlooking the Bayou Bienvenue Wetlands Triangle in New Orleans's Lower Ninth Ward was also built. By 2009, it began functioning as a community classroom and gathering place. Photographers, fishermen, and university students frequent the platform to this day, taking in the view of the bayou and the Industrial Canal.

The wooden platform, outfitted with a canopy roof and handrails on either side, was designed by landscape architects and built with the help of professionals, students, and community volunteers. Educational opportunities in the form of field trips, scientific experiments, environmental research, and community science activities are only a few of the uses of this historic mainstay that signifies a connection of hope for a community that was devastated by Katrina in 2005. Local high school-age environmental research interns have been tasked

with testing the temperature of the water and soil as well as monitoring air that flows through Bayou Bienvenue. These exercises are carried out to enhance the growth and development of our underserved community.

Embracing community is essential, particularly in a world where risk and aid have become so individualized. There's something beautiful about coming together to recognize the splendor and power of relational ecosystems in the face of climate change. This means working to teach residents about their environment and how to use science, conservation, and sustainable practices to enrich and protect it.

A critical part of this education is helping folks see and value the bayou differently. Our wetlands have a delicate and critical ecology with various plants that prevent soil erosion. They're not supposed to be manicured and conform to other landscaping standards. It's a natural habitat. The birds and everything you see are a haven right in our own backyard.

More than 90 percent Black, the Lower Ninth Ward is a microcosm of a larger truth: communities of color across the globe often suffer the most from climate change while doing the least to contribute to it.

Community activists and environmental community-based nonprofits are changing the way the neighborhood's most vulnerable inhabitants can recover from and become resilient to natural disaster, aiming to train its young people in ways that can be recreated in other cities, too.

What Will They Write About Us?
Jessica Dandridge

A colleague recently asked me a question I had never considered before: "If the world was utopia and the climate crisis didn't exist, what would you do? Who would you be?" I paused, my soul shaking at the idea because my desires are buried in a mausoleum with the ancestors in Metairie. After a moment's hesitation, I responded proudly, "I'd be an anthropologist or an Egyptologist." My colleague looked at me lovingly, smiled, nodded, and said, "Thank you, wasn't that refreshing?" I continued to think about this conversation for days and weeks after. Shit, I'm writing about it now. How could such a basic question shake my spirit so completely?

I go to bed late, usually trying to quiet my brain from the never-ending list of tasks that have piled up for the next day. In order to stave off burnout and depression, I have a strict bedtime routine that includes watching celebrity gossip YouTube shows while I brush my teeth. When I lie down, I put history documentaries on in the

dark with my diffuser set on red, which apparently helps me sleep better. With the covers over my head, I listen to how civilizations, centuries ago, rose and fell – stories of kings and queens and their empires. I listen to stories about religion and mythology, gold and bronze. In my mild obsession, I have found that many of these documentaries are devoted to speculative histories, ones that piece together visions of these civilizations beyond what little the historic record actually offers us. Babylon, the Maya civilization, Atlantis – what we know of these civilizations is often anchored in well-crafted theories, not hard facts – although many of these theories have been etched into truth for someone, somewhere. Perhaps some of these videos are based on the oral histories and long-gone memories of community elders. Either way, storytelling, and perhaps historymaking, is a game of telephone, with each generation's facts and fables intertwined, irrevocably.

As a Katrina survivor, I notice how the memories that are replayed in the broader public's mind and media portrayals alike are often more reflective of other peoples' biases, perceptions, and the voices of an ignorant aristocracy. The collective memory of New Orleanians is so distinctly different from the depictions broadcasted beyond Louisiana that it often feels inevitable that lasting memories will never be our own to define – that we do not and never will own our story.

And yet, the stories of our mothers, grandparents, and ancestors feed our souls and pave our yellow brick roads. Stories of triumph and challenges, resilience and love. They give us hope in a world where life is a dystopian sitcom. In Louisiana, our stories give us energy. In a place where pain is passed down and violence is a rite of passage, we live life to its fullest, waiting for the day when Mount Vesuvius erupts and our memories are encased in igneous rock. Louisiana is suffering through the nightmarish consequences of pollution and climate change, but because these are all too challenging to process, storytellers in the national media instead focus on crawfish and swamp tours. It's too dark, so they paint it in brighter colors – colors of resilience, with splashes of strength. There are no colors for weariness or anger – we are eternally painted as happy, friendly, and funny. Louisianians are also painted as a joke, as clowns in our own sinking circus. We are entertainment for the masses, extracted from and humiliated simultaneously, stripped of humanity and blamed for our poor circumstances. In all of this, I can't

help but wonder, what will they write about us and will this be our forever legacy?

Will they write that we could've done more to save ourselves from mass extinction, but we were too set in our ways to leave — just like they say about the Mayans? Will they write that we fled at the last minute while our history, culture, and technological advancements fell deep into the sea? Or will they write that we were so dysfunctional and cruel that God himself had to do away with us? Whatever they write, I know it won't be gentle, and it won't be kind. As the metaphorical and literal boot of the United States, we are blamed for our woes, even though our circumstances aren't our own to carry. American greed has fueled our demise. The elite consume fossil fuels like air and ask us why we are choking. Other people's cheap disposables come up through our waterways, polluting and sinking communities; our rich soil is forever razed of nutrients, but it remains our fault that those responsible have yet to clean up the mess they've made.

After Katrina, as a refugee in my own country, I was blamed for everything that I could not change. And when we try to save ourselves, we are called selfish country bumpkins, or worse. And when nature finally runs its course, the climate activists of New York and California will say that we weren't eloquent enough and we didn't have enough PhDs and JDs to make a difference. Regardless of what we say, the challenges facing a poor city — which started off as a fort and then grew due to the transatlantic slave trade — are solely placed on the victims of government-sanctioned violence and trauma. The blame will lie solely in our laps, and my children's children will either be ashamed or proud that we survived despite the odds.

After we sink into the sea, our artifacts of toxic plastic beads, hand grenade cups, guns, and oil pipelines will tell the story. A thousand years from now, man will paste together the evidence. Long after the Mississippi River reclaims her throne and our homes have deteriorated into the sea, will we be given humanity and empathy?

If things were different, I'd definitely be an anthropologist. But the more I think about it, I'm already acting as one for Louisiana. I love this city and this state. It is filled with deep love. Our joy could be considered unhinged, and our traditions nonsensical, but they're ours to cherish. I work in water justice not only to preserve our state, but to make sure that

we own our narrative. From the people who toiled and built the land to the people who swam in the flood water and survived another day. From fisherfolk to teachers and engineers, we must tell it ourselves because I don't know what they'll write about us, but I know what we will.

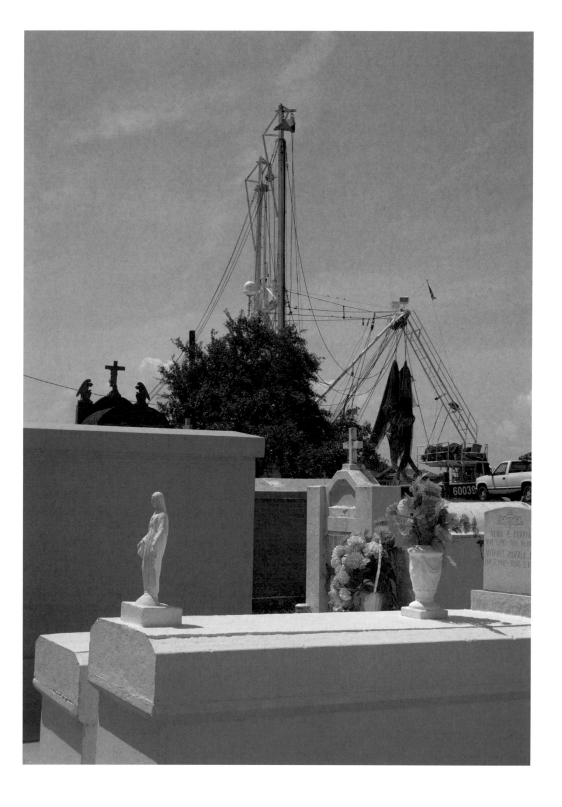

Cemetery Near Bayou Barataria, Lafitte, 2021

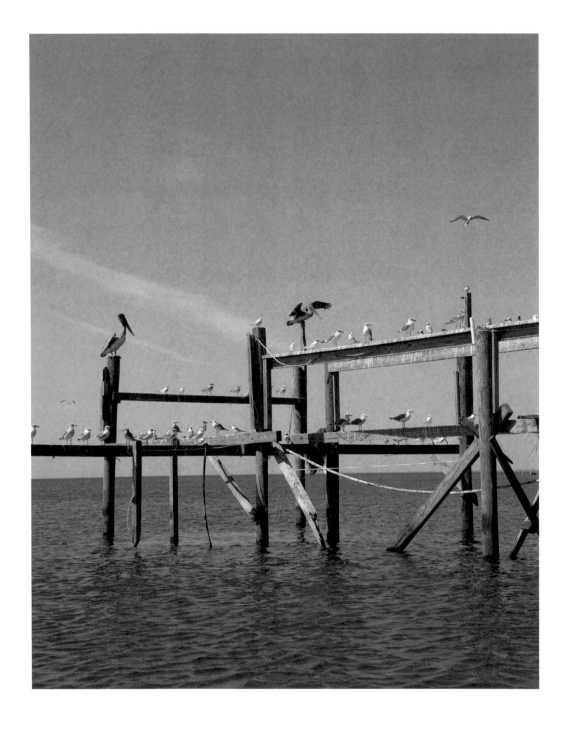

Lake Maurepas after Hurricane Ida, 2022

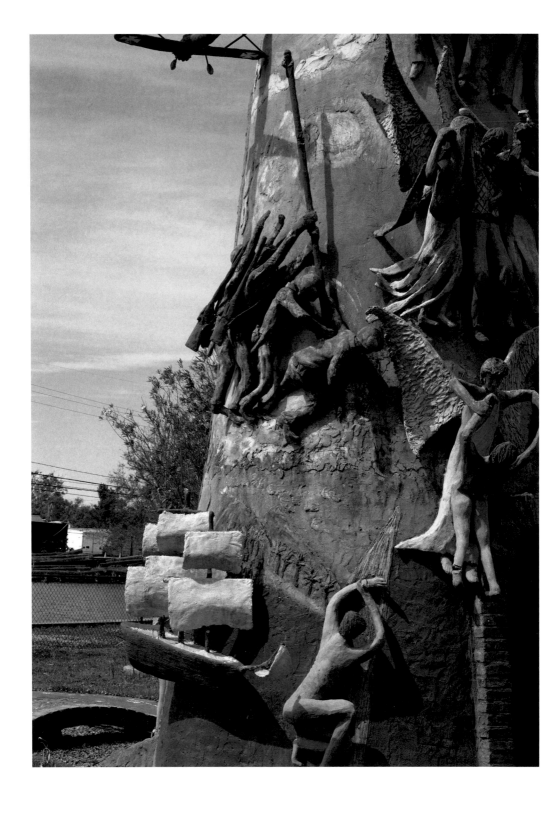

Chauvin Sculpture Garden, Terrebonne Parish, 2023

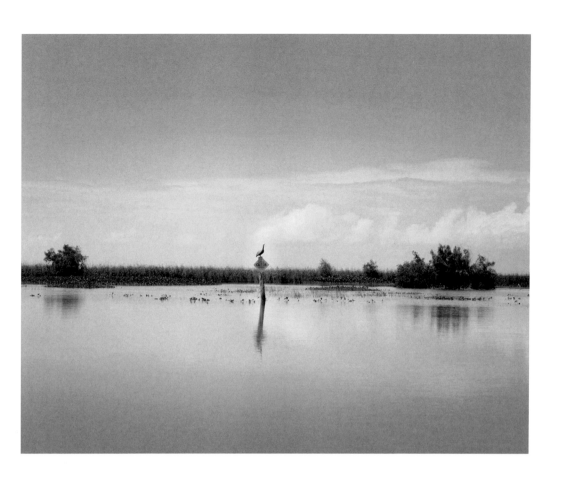

Marsh Near Bay Denesse NO.1, Plaquemines Parish, 2021

What shatters the stillness of the captured moment
Imani Jacqueline Brown

One hundred years ago, the first oil and gas corporations arrived in the Mississippi River Delta, chasing rumors of her riches.[1] Not her grand biodiversity, which she paraded with pride, but her closely held secrets: some of the greatest stores of oil and gas in the United States.

The wetlands of the Mississippi River Delta carry themselves with a trickster energy. Slowly, imperceptibly, they shudder and shape-shift, appearing as land one moment and water the next. Yet their winking subterfuge was ultimately no match for the voracious greed driving extractivism. Once they realized they could not tame the wetlands, extractivism's agents stripped away their skin. Ten thousand miles of canals were dredged through murky meshes of marsh grass and sediment to drill 90,000 oil and gas wells, which connect to hundreds of refineries via 50,000 miles of pipeline.

For over one hundred years, water and

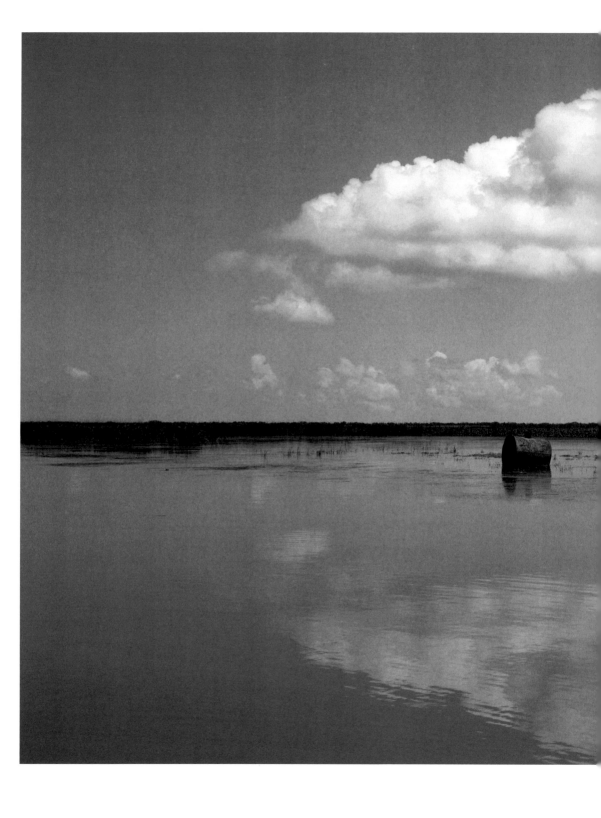

Marsh Near Bay Denesse NO.2, Plaquemines Parish, 2021

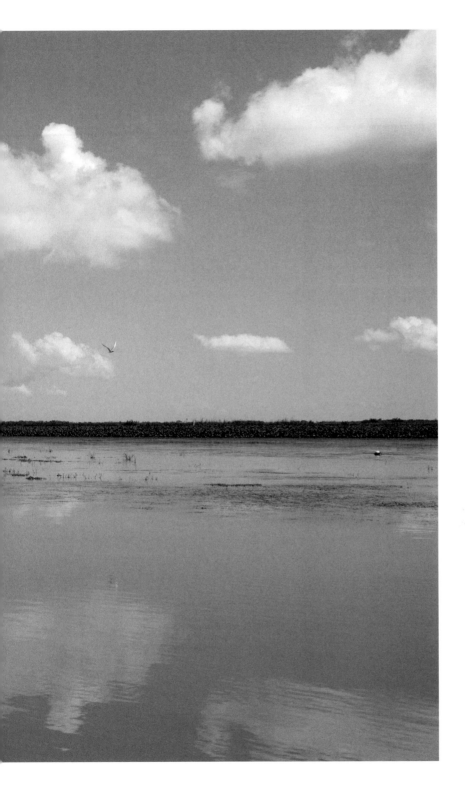

oil, birds and drums, people and pipelines have cohabitated in Louisiana's marshlands. Ours is an uneasy coexistence based not on a truce but on tension and time – borrowed time. White birds cast twelve-o'clock shadows black with oil from spills past and future. Our extinction clock's second hand jitters a few beats to midnight; a second line for the world as we know it marches on the horizon.[2]

The oil industry's infrastructure has forced the wetlands of the Mississippi River Delta to bear one of the fastest rates of coastal erosion in the world. One football field of land is lost every forty-five minutes; 2,000 square miles have been lost in less than one hundred years.

But if Louisiana's wetlands have been lost, who lost them? No hands raised, no names named. A territory conquered without flags. Yet the architects of our disintegration are knowable, perceptible. We see their logos planted like colonizers' flags on our schools and festivals, emblazoning our basketball courts and lurking within our courts of law – a crude diversion.

Extractive infrastructure's material residue shatters the stillness of the captured moment. An oil drum here, a warning sign there. A pelican cries. A gale blows. A chemical odor drifts. A fragment of land disintegrates into the sea.

Thinking like oil, we can traverse the wider ecologies in and beyond this fragmented frame. We can flow through the submerged pipeline upriver to the "Petrochemical Corridor." There, hundreds of formerly slave-powered sugarcane plantations, which drained and concretized fluid ecologies stewarded by Indigenous peoples, have been occupied by hundreds of toxic industrial plants. The continuum of extractivism comes into view.

Beyond the frame, the Indigenous communities of this place are pushed from their upriver ancestral homelands. Beyond the frame, their descendants face the rising seas, elevate their homes, refuse further dispossession. Beyond the frame, fifteen enslaved people dig a plantation well and strike natural gas, inaugurating the fossil fuel era.[3] Beyond the frame, their descendants look to the petrochemical horizon, consider exile, choose resistance.

1 I choose to use she/her pronouns when
 referring to the Mississippi River Delta
 following the practice of global Indigenous
 readings of our ecologies, which see them
 as generative.

2 For more on the "extinction clock" see
 https://extinctionclock.org. A second line
 is a form of funeral procession in Louisiana,
 a West and Central African cultural
 retention in which the "first line" – the
 coffin and brass band – is followed by a
 "second line" of mourners celebrating the
 life of the deceased.

3 "The first chapter in the romantic history
 of natural gas in Louisiana begins with
 a picture of fifteen husky Negro slaves
 laboriously toiling under a crude tripod
 on the banks of Cane River at Bermuda,
 10 miles south of Natchitoches [Louisiana]."
 Louisiana Conservation Review (Spring
 1938): 38.

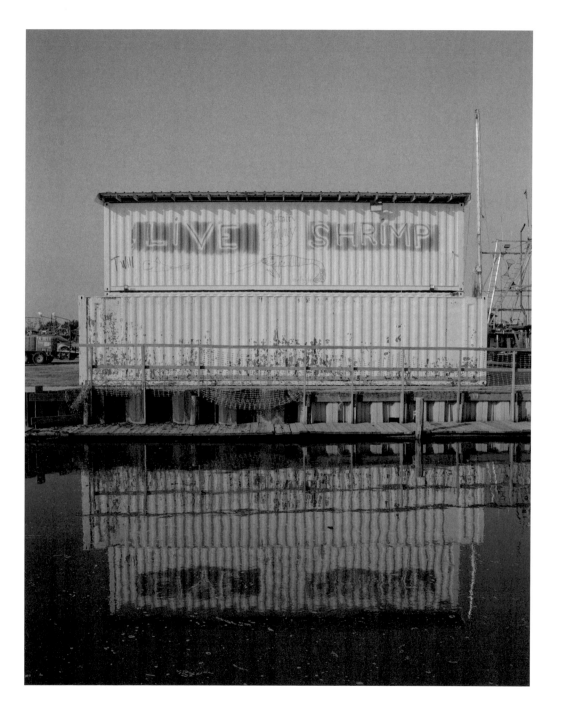

Pelican Pointe Marina, Orleans Parish, 2022

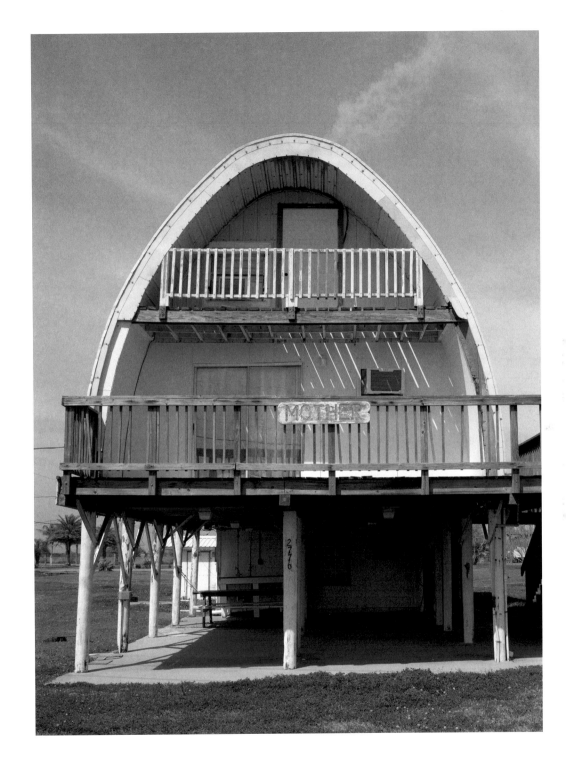

Mother House, Grand Isle, 2020

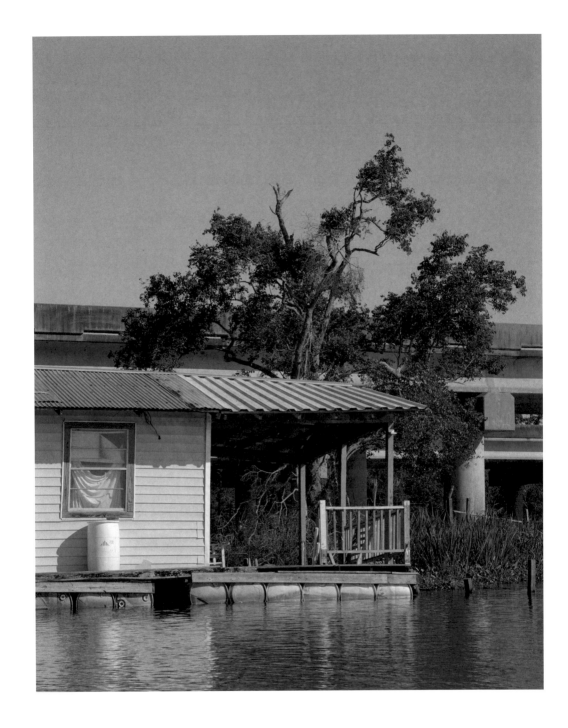

Houseboat Near Route 55, Lake Maurepas, 2021

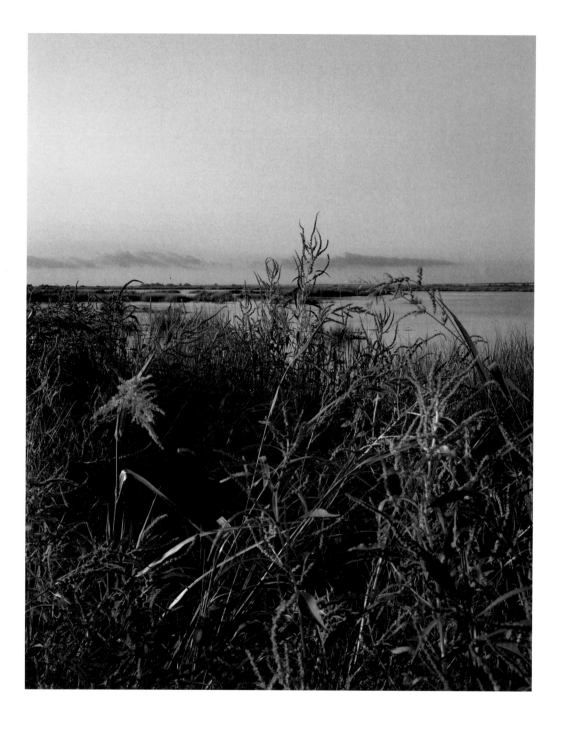

The Great Wall of Louisiana NO.1, 2022

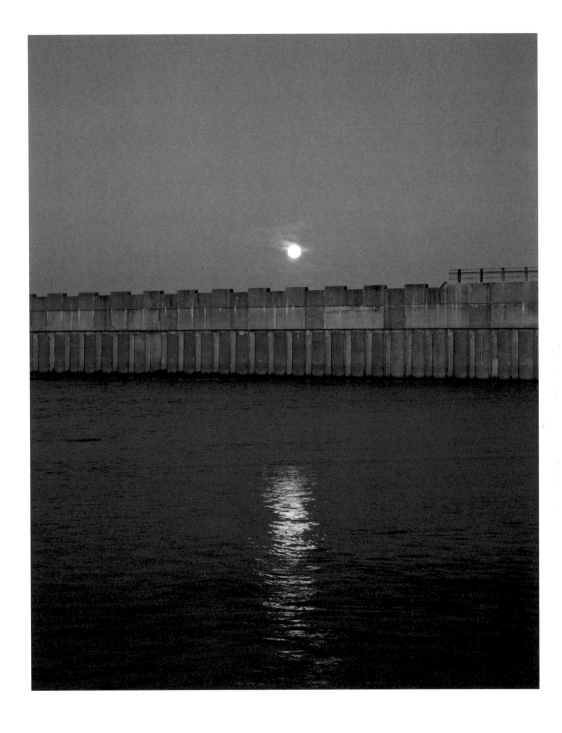

The Great Wall of Louisiana NO.2, 2022

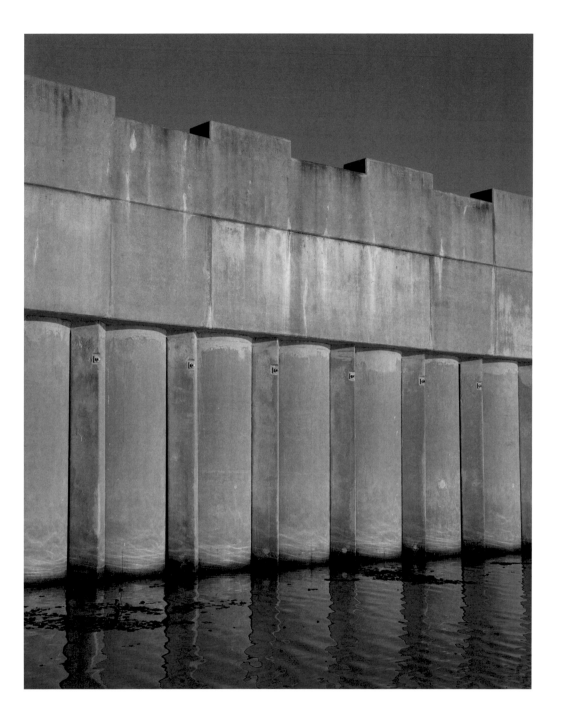

The Great Wall of Louisiana NO.3, 2022

What Would Happen
Andy Horowitz

Pete Savoye was among those throwing rocks into the channel on March 28, 2009, from aboard a 65-foot oyster boat called the *Donna Ann*. Savoye and several dozen others were making what the St. Bernard Parish president described as "a symbolic gesture for

the residents of St. Bernard closing the MR-GO themselves."[1] The MR-GO, or Mississippi River-Gulf Outlet, was a 76-mile-long channel connecting the Gulf of Mexico to the Intracoastal Waterway and the Industrial Canal, and St. Bernard residents had been trying to close it since the day it opened. Nobody had tried harder than Savoye.

Savoye was twenty-seven years old in 1957, when Louisiana's senators and congressmen pushed the ceremonial plunger, detonating dynamite that was carefully packed along the marshes surrounding Lake Borgne to begin construction on the MR-GO. In New Orleans, the *Times-Picayune* called it a "helpful explosion for world trade." The newspaper reported that once the US Army Corps of Engineers dredged the channel, the new shortcut for large ships from the Gulf to the city would increase business at the Port of New Orleans.[2] The *St. Bernard Voice*, whose readers lived closer to the channel, was more skeptical. Its headline read, "IS ST. BERNARD PARISH DOOMED."[3] The editor did not bother with a question mark.

It was common knowledge, even before construction, that the MR-GO would endanger St. Bernard Parish, the coastal county east of New Orleans. It was obvious that during hurricanes the channel would funnel storm surges straight from the Gulf into St. Bernard and New Orleans. That first happened in 1965, during Hurricane Betsy. The Betsy flood prompted Congress to authorize a new hurricane protection system for metropolitan New Orleans, but the levees did little to mitigate the vulnerabilities created by the MR-GO; the Army Corps later acknowledged that its hurricane protection system was a "system in name only."[4]

When Savoye would go out fishing, he saw how the MR-GO brought salt water into the marsh. First the crawfish fled. Then the cypress trees died. Eventually, the marsh itself began to collapse. The MR-GO grew nearly 50 feet wider every year. Meanwhile, the channel required expensive maintenance, other cities also upgraded their ports, and the big ships never came.

As president of the St. Bernard Sportsman's League, Savoye for years lobbied for the Army Corps to close the channel. In the early 1990s, he and other league members built a 3-foot square model of St. Bernard out of plywood and used it in demonstrations across the parish. "To show people what would happen," he explained during a deposition in 2008, "I would pour blue water in the

Gulf of Mexico and put a break in a levee, and when I would put a break in the levee, then it would flood all of St. Bernard Parish and Orleans Parish."[5] That is what happened in 2005, during Hurricane Katrina: more than one hundred people in St. Bernard died in the flood, and many hundreds more died in New Orleans. Savoye offered his deposition on behalf of a case pressing for compensation for flood victims, but the Flood Control Act of 1928 indemnified the federal government from flood damage claims, and the case was dismissed.[6]

That history must have been on Savoye's mind that spring day in 2009, giving an extra weight to the rocks he dropped in the water to ceremonially mark the closing of the MR-GO. The Army Corps added 433,000 tons more stone, building what Virginia Hanusik calls "The Great Wall of Louisiana." The Army Corps calls it the Lake Borgne Surge Barrier: a 1.8 mile long, 25-foot-high wall stretching across the MR-GO, the Gulf Intracoastal Waterway, and what is left of the Golden Triangle Marsh along Lake Borgne. It is meant to stop further saltwater intrusion, and to buffer future storm surges. The Army Corps finished constructing the barrier in 2013 and asserts that it can protect against a so-called hundred-year storm surge from the Gulf or one that has a 1 percent chance of coming each year.[7] Like much of the infrastructure that structures our lives, it often remains out of sight or blends with the landscape. It is taken for granted. That is, until it cannot be.

Savoye died in 2013. The model that he and his colleagues in the Sportsman's League built is now behind glass in New Orleans, a specimen in the Louisiana State Museum's exhibit about Katrina. To some, the artifact may recall the prescience of those who long understood the threat the MR-GO posed; to others, it may recall the fatal refusal to heed their warnings.

Hanusik's depiction of the surge barrier, in a triptych, suggests something similar about the diversity of our perspectives. Life in Louisiana is so fractured across lines of race, class, topography, and all the rest, as to trouble any assumptions about a singular point of view. We look at the same infrastructure and see different things, because we have different relationships with it. The wall is a monument to engineering's power, and a memorial to engineering's failures. It is a symbol of strength, and a symbol of vulnerability. It embodies a democratic effort at ambitious public works, and a technocratic panacea refracted

through a thousand subcontractors. It stands as a federal commitment to protecting Americans regardless of race, class, or creed; and it stands like a concrete back turned to those who are outside of its embrace. We may be moved to ask, what arrangements does the wall mean to preserve, and why?

1 "Dozens Seize Chance to Help Close MR-GO," *New Orleans Times-Picayune*, April 9, 2009, 9; John Pope, "Charles 'Pete' Savoye, 83, an Early, Vocal Opponent of MR-GO, Has Died," *New Orleans Times-Picayune*, December 31, 2013, A21.

2 "Helpful Explosion for World Trade," *New Orleans Times-Picayune*, December 10, 1957, 12.

3 "Is St. Bernard Parish Doomed," *St. Bernard Voice*, November 15, 1957, 1.

4 Interagency Performance Evaluation Task Force, *Performance Evaluation of the New Orleans and Southeast Hurricane Protection System*, VOL.1 (US Army Corps of Engineers, 2009), 127.

5 Charles George "Pete" Savoye, deposition transcript, March 5, 2008, 39–77, *In re Katrina Canal Breaches Consolidated Litigation*, US District Court, Eastern District of Louisiana, Civil Action NO.06-2268.

6 This essay is informed generally by Andy Horowitz, *Katrina: A History, 1915–2015* (Cambridge, MA: Harvard University Press, 2020). See especially pages 81–85 (for the MR-GO) and 132–133 (for the lawsuit).

7 US Army Corps of Engineers, "IHNC-Lake Borgne Surge Barrier," updated June 2013, https://www.mvn.usace.army.mil/Portals/56/docs/PAO/FactSheets/IHNC LakeBorgneSurgeBarrier.pdf.

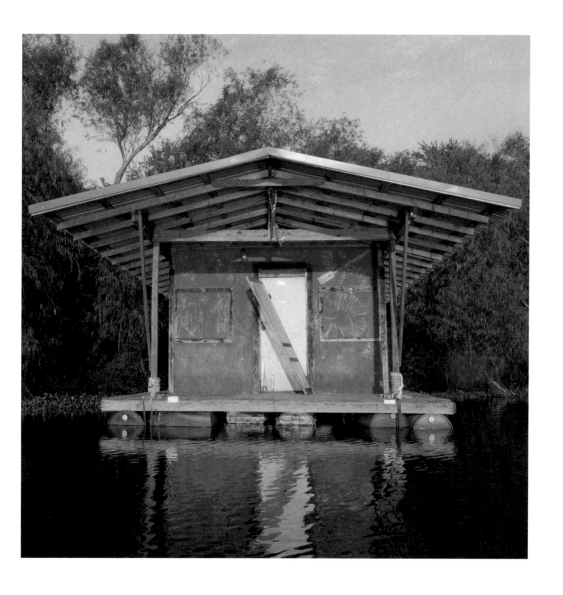

Houseboat on Lake Maurepas, 2015

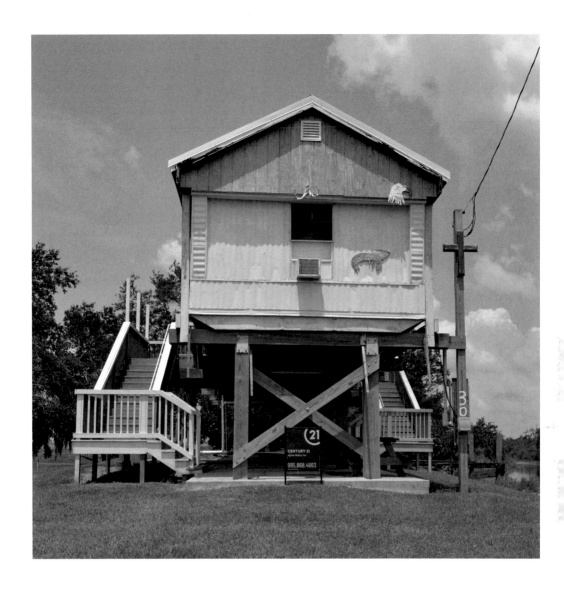

House for Sale, Isle de Jean Charles, 2021

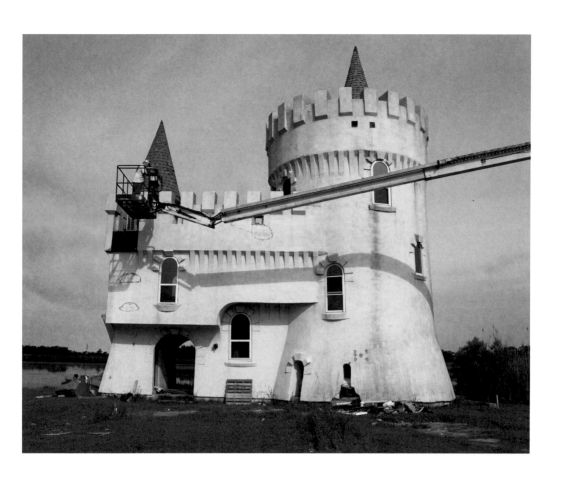

Irish Bayou Castle, Orleans Parish, 2022

Why Are We Saving New Orleans?
Amy Francis Stelly

 Our land is disappearing.
 Our castles are crumbling.
 Our children are leaving.
 Our neighbors are gone.
 So, why are we saving
New Orleans? Who are we saving her for?
 We've endured more than
a century of Mother Nature's brutal storms.
 Please give us a
 moment of silence…

2021	Hurricane Ida	1971	Tropical Depression	
2021	Tropical Storm Claudette	1969	Hurricane Camille	
2020	Hurricane Zeta	1965	Hurricane Debbie	
2020	Tropical Storms Amanda and Cristobal	1965	Hurricane Betsy	
2019	Tropical Storm Olga	1964	Hurricane Hilda	
2017	Hurricane Nate	1960	Hurricane Ethel	
2012	Hurricane Isaac	1957	Tropical Storm Esther	
2011	Tropical Storm Lee	1956	Tropical Storm	
2010	Tropical Depression Five	1955	Tropical Storm	
2010	Tropical Storm Bonnie	1955	Tropical Storm Brenda	
2008	Hurricane Gustav	1949	Tropical Storm	
2005	Hurricane Katrina	1948	Hurricane	
2005	Hurricane Cindy	1947	Hurricane	
2004	Tropical Storm Matthew	1947	Hurricane	
2003	Tropical Storm Bill	1945	Tropical Storm	
2002	Hurricane Isidore	1944	Tropical Storm	
2002	Tropical Storm Hanna	1939	Tropical Storm	
2002	Tropical Storm Bertha	1936	Tropical Storm	
2001	Tropical Storm Allison	1936	Tropical Storm	
1998	Tropical Storm Hermine	1932	Tropical Storm	
1998	Hurricane Georges	1926	Hurricane	
1997	Hurricane Danny	1926	Hurricane	
1988	Hurricane Florence	1923	Tropical Storm	
1988	Tropical Storm Beryl	1923	Hurricane	
1985	Hurricane Juan	1923	Tropical Storm	
1985	Hurricane Elena	1915	Hurricane	
1984	Tropical Depression	1914	Tropical Storm	
1980	Tropical Depression	1912	Tropical Storm	
1979	Hurricane Bob	1911	Hurricane	
1978	Tropical Depression	1907	Tropical Storm	
1977	Tropical Depression	1906	Hurricane	
1977	Hurricane Babe	1905	Tropical Storm	
1976	Tropical Depression	1901	Hurricane	
1975	Tropical Depression	1900	Tropical Storm	
1975	Tropical Depression	1895	Tropical Storm	
1971	Hurricane Fern	1893	Hurricane	
1971	Tropical Depression	1893	Hurricane	
		1892	Tropical Storm	

1890	Tropical Storm	1872	Tropical Storm
1889	Hurricane	1869	Hurricane
1887	Hurricane	1867	Hurricane
1887	Tropical Storm	1863	Tropical Storm
1885	Hurricane	1860	Hurricane
1879	Tropical Storm	1860	Hurricane
1879	Hurricane	1855	Hurricane
1877	Hurricane		

We are slowly but surely becoming climate migrants as we flee.
Hurricanes. Tornadoes. Flooding. Tropical storms.
We rebuild only to be stricken again and again.

> So, why are we saving
> New Orleans?
> Who are we saving her for?

Tourism has taken over the land.
New Orleans is the new Disney World.
They're historically connected places, you know.
Walt Disney considered New Orleans East a mecca before settling on
Central Florida.

> Visitors outnumber
> us forty-two to one.

> Our streets are movie sets.
> In the dead of night, their blinding
> lights carve figures into the walls
> of our cells.
> We must remain silent and hidden
> behind locked doors and wooden
> walls as they take over our streets.
> They roam our hallowed halls,
> proclaiming glory.

> So, why are we
> saving New
> Orleans?
> And who are we
> saving her for?

But deep below the surface, the system rumbles.
Then it blows!

Methane gas finds folks in their sleep.
Fires flare from beneath a dark, quiet street like
an angry dragon's wild breath.
Manhole covers fly through the cool night air,
crushing cars that stand in their way.

> There are just too many of us.
> The city can't take it anymore.

So, why are we saving New Orleans?
And who are we saving her for?

> Yet, festival after festival draws
> tourist after tourist.
> Homes have morphed into hotels.
> Indigenous residents are seen merely as
> props – cardboard cutouts of the people
> who make New Orleans New Orleans.

Our leaders have sold our city.
Our leaders have sold their souls.
They have traded away our lives for
elusive piles of gold.

> It's out with the old! In with the new!
> Tourists are the new citizens.
> The original New Orleanians must be removed!

So, why are we saving New Orleans?
And who are we saving her for?

> We are:
> Victims of climate
> Victims of crime
> Victims of pollution
> Victims of corruption
> Victims of ignorance
> Victims of poverty
> Victims of greed
> Captives of wealth.

> Puppet masters vie for
> a city that once was.
> Chaos rules the day.
> Our city has become
> a sad, mad place. 104

So, why are we saving New Orleans?
And who are we saving her for?

We are saving New Orleans because
we love her.
We dance in her streets.
We revel in her beauty.
We marvel at her soul.

We must help her
save herself.
We must celebrate
Bulbancha and
listen to the wise
spirits of the most
sacred Congo
Square.
They have told us
not to let the
homeland go.

So, guard the castles. Protect every man.
We must save New Orleans.
We must save our fragile land.

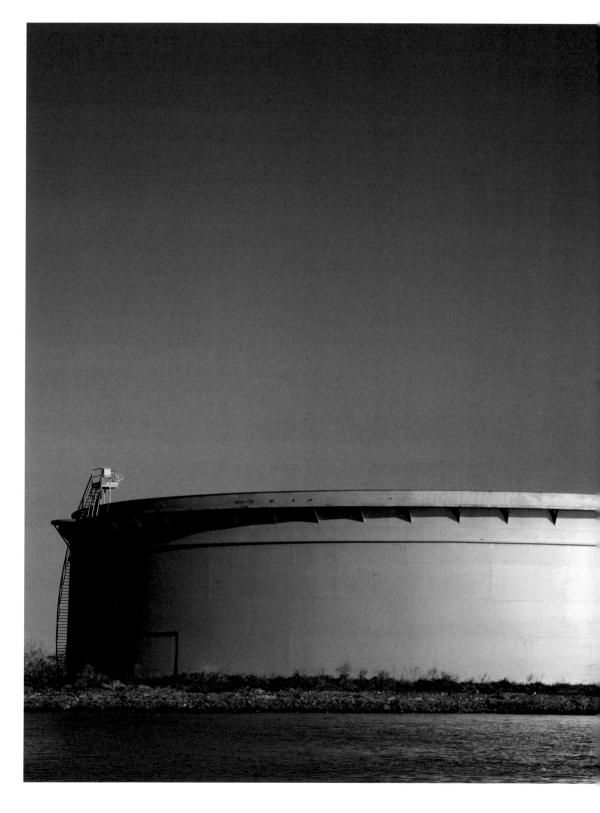

Oil Infrastructure on the Mississippi River, Lower Plaquemines Parish, 2022

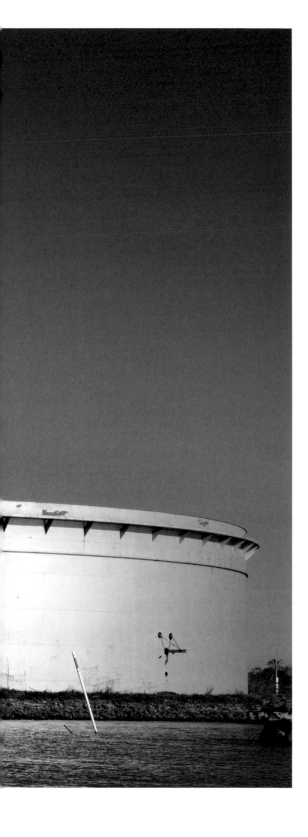

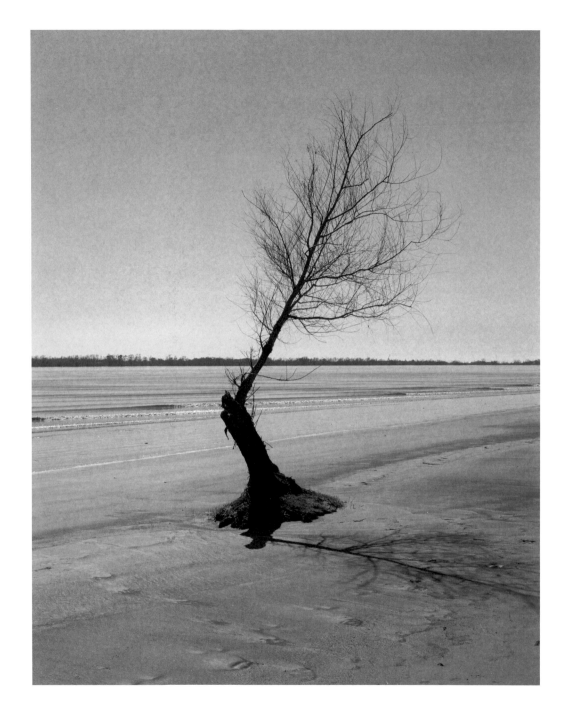

The Mississippi River Near Fort St. Philip, Plaquemines Parish, 2022

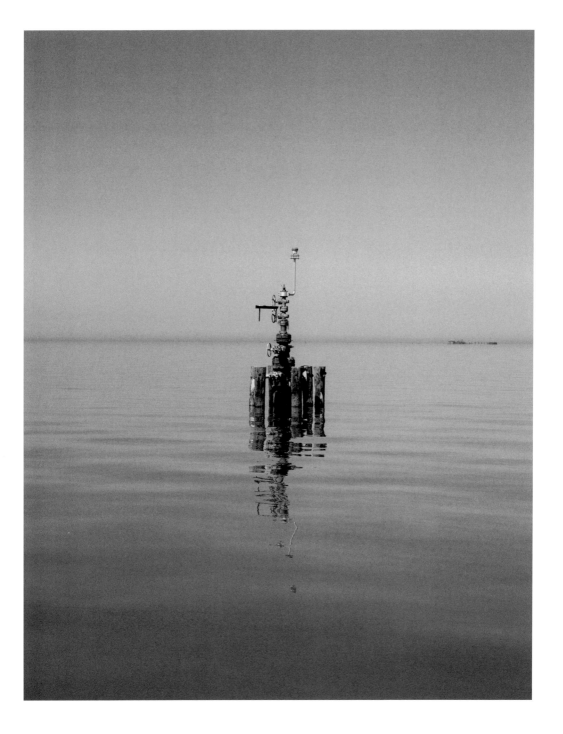

Abandoned Oil Infrastructure, Plaquemines Parish, 2022

Portals and Instruments
Billy Fleming

 I am a wellhead within Louisiana State QQ Lease 195 136D
and I have been hurtling toward this location for at least 5.3 million
years. The deposition and accumulation of biotic material during

the Miocene era helped produce one of the largest oil and gas fields on Earth: the broader coastal plain of the Gulf of Mexico. I was not destined to arrive here. But, once the formation of the Dutch East India Company helped give the world an economic system now known as global capitalism, and once the Transatlantic Slave Trade delivered racial capitalism to the West (both in the sixteenth century), the table became set for the kind of extractivism that would require a field of wellheads like me. When the Industrial Revolution gave rise to a more energy-intensive society at the end of the nineteenth century, a range of exploratory drilling technologies were deployed in the vast, energy-dense reservoirs of oil and gas beneath the Gulf of Mexico. In a world built by global and racial capitalism, there will always be places like this (resource communities and dumping grounds) and instruments like me (tools to access the wealth below the surface). But other worlds are possible, and I dream of the day that I might be decommissioned. Yet, I fear I will be in this place longer than most of the people reading this will be alive.

 I am one of 322 completed wellheads in the area – though only twenty-three have been used for active extraction operations (including me). The others were either exploratory or relief wells – the former are drilled in bunches and help platform workers decide where to drill their primary well(s); the latter are created as the primary wells are developed and act as a fail-safe in the event of a blowout or technological failure (you may recall that these wells had to be dug in real time during and after the BP Deepwater Horizon oil spill).[1] Developed in 1937, the Quarantine Bay section of this oil field has produced 188 MMBOE (millions of barrels of oil equivalent) of crude and 322 billion cubic feet of gas since large-scale operations began in the 1970s.[2] To access the oil and gas deposits, drill operators must contend with: 4 – 8 feet of seawater and some of the thickest clay and mud on any seafloor in the world; once they punch through those, it's another 500 feet of drilling to reach the first tranche of oil and gas, most of which was exhausted in the 1990s. The rest of the oil field sits somewhere in a layer of sediment from the Miocene era – strata that range from 5,800 – 11,000 feet below the seafloor, in rocks at least 2.6 million years old. I was plugged and abandoned in 2017.[3]

 I am comprised of several components – these include a casing head, spool, and hanger, each made of alloy steel; a tubing head and hanger, also made of steel; and a mudline suspension system, to

allow for disconnection and reconnection when new methods of extraction are invented that might unlock deeper deposits of oil and gas here. Most of the steel I'm made of was smelted in facilities along the Lower Mississippi River and purchased through Express Supply & Steel – a company that would later sue my own parent company, Cox Oil, as it went through bankruptcy proceedings.

I am a portal into the past and the future, across space and through time. I am the instrument through which millions of years of geologic and ecologic work is removed from the Earth's crust, shipped to refineries, and divided into various forms of fuel and petrochemicals. I am a site of historic and ongoing contestation for climate justice advocates – a symbol and cause of the planetary climate crisis and the centerpiece of just transition proposals for a federal jobs guarantee that would include plugging and decommissioning abandoned wells.[4] I am a piece of technology that must be rendered obsolete and replaced by renewable energy sources if life after this century is to remain livable for humans and nonhumans alike. I am a purveyor of the various harms that the fossil fuel industry has brought to this planet – the climate crisis, the sixth extinction, and the various health and quality-of-life impacts that come from breathing in the benzene, toluene, and other pollutants that come from burning me for fuel. I have withstood hurricanes, direct action and protests, and even catastrophic fossil fuel disasters in my immediate proximity. I will be here until people decide to stop poisoning their planet and each other.

I am a wellhead within Louisiana State QQ Lease 195 136D.

1 N. M. Fenneman, "Oil Fields of the Texas-Louisiana Gulf Coastal Plain," United States Geological Survey, Bulletin no. 282 (Washington: Government Printing Office, 1906), https://doi.org/10.3133/b282. See pages 66 – 79 for an extended discussion on oil and gas well types, the various levels of pressure exerted at the depths of the oil field, and the need for relief wells more generally.

2 "Louisiana State QQ Lease 195 136D: API NO.17-075-01365: Gulf Oil Corp.," *DrillingEdge*, https://www.drillingedge.com/louisiana/plaquemines-parish/wells/louisiana-state-qq-lease-195136d/17-075-01365.

3 Cox Oil, "Quarantine Bay Field, Plaquemines Parish, Louisiana," Technical Report 0032, https://coxoperating.com/footprint/quarantine-bay.

4 For more on this, see J. Mijin Cha, et al., *Workers and Communities in Transition: Report of the Just Transition Listening Project* (Takoma Park, MD: Labor Network for Sustainability, 2021), https://www.labor4sustainability.org/jtlp-2021/jtlp-report.

Distance, Empathy, Transformation
Aaron Turner

 Family, labor, economics, housing, and land always intersect, regardless of how you turn the tables. Since the last round of hurricanes that hit Louisiana in 2020, dozens of insurance companies have

filed for bankruptcy, which means they've either canceled existing policies or announced that they won't renew them. During the summer months of 2023, several more companies announced they were pulling out of states like Florida, citing similar reasons related to hurricanes, and California, due to its increasingly destructive wildfires.[1] The dissolution of financial support systems is just one of the many ways climate change will continue to affect our everyday lives beyond weather-related damages.

Given my own relationship with and research into South Louisiana's changing environment, I have found that people are already aware of the unfortunate events that are overtaking places in this region – like many other places around the world – from the development of Cancer Alley to the loss of marsh land on the coast. I often think that the key to moving forward through this change and loss is not by reproducing the trauma associated with it, but by figuring out who is responsible and what to do about it.

As an artist, I wish to emphasize the transformative quality of photography and the photograph. Photographs carry so much information: they are pieces to a puzzle, parts of a bigger story. Photographs can cultivate change in how we understand ourselves in relation to what's going on in the frame (or beyond it), creating opportunities for critical thinking.

My oldest brother is a landscape architect and college professor. He and his students work directly with communities by collecting oral histories and discussing how to alleviate food deserts and improve the use of public space. My brother and I often find ourselves talking about the small town we grew up in West Memphis, Arkansas, a region flanked by the Mississippi River and levees, which are built around the city. Heavy industrial factories and their pollution lie |near the river, and flooding is a regular occurrence when it rains. Though it is environmentally similar to areas like South Louisiana, that's not the connection I'm drawing here; it's more about resilience. We were told to leave our small town and state by family, schoolteachers, and other residents: "Go make something of yourself"; "There are no opportunities here"; "Go to college, don't come back."

This is what encouraged me to embrace transformative thinking in my own photographic work documenting the Arkansas Delta, to not look away

from it, to engage with these landscapes and to believe others are capable of this too. It's hard to go back and depict a mood or feeling from conversations you've had over the years, so I work from memory, mood, and mementos.

Along with its emotive power, photography is often made to carry the burden of compiling historical information to spark or reinforce critical thinking. The elements in this image, for instance, provide a beautiful yet haunting point of encounter with the abandoned remnants of oil infrastructure. The space of the water and the almost endless horizon offer room for contemplation – but that contemplation can also conjure a harsh reality.

I wonder what used to be here? What had to be eliminated to place this infrastructure here?

Photographs can also challenge our belief systems. They both depict reality and, as a mode of mediation, ask us to question it, which means two things can be true at the same time. Photography can also be an empathetic method of communicating with others when shared with the intention of fostering new dialogue.

Abandoned Oil Infrastructure, Plaquemines Parish, 2022 provides that space of empathy wherein the ruins of the petrochemical industry detail a longer history of waste and corruption. Looking at the abandoned oil infrastructure from my perspective, I know this landscape to be a former marshland, now transformed by a battle between salt and fresh water, eroded by a manmade intervention for a mineral resource.

Shell Billboard, Highway 90, Des Allemands, 2023 achieves this empathetic gesture in reverse. Despite what the slogan on the billboard suggests, Shell has devastated the region through oil extraction and processing that endangers the very same residents it purportedly works to safeguard and uplift. Considering the state's disappearing coastline in the Gulf of Mexico, the depiction of the advertisement is a dark, humorous gesture. Here, photography allows us to look at the past and present simultaneously and to speculate on what is possible in the future. We must act on these revelations.

The realities of loss, memory, time, and irony depicted within these photographs outline circumstances that we, as a society, must respond to. Distance, as offered by photography, is

key to developing that response. For me, photographic distance is less about the focal attributes of the photograph and more about lending an ability to sit with a subject, thought, or idea in contemplation. A photograph in printed form can bring you close to a topic but at the same time it keeps you at a safe vantage point. I think somewhere in the middle, between proximity and safety, lies the space where we decide to act or not. It is up to us to choose whether or not we want to change what we are looking at to uplift this rich and historical coastal landscape.

1 See Taylor Kate Brown, "Property Insurance Disappears for Louisianans – but Not for Gas Facilities," *Guardian*, July 24, 2023, https://www.theguardian.com/environment/2023/jul/24/louisiana-property-insurance-residents-gas-terminals; Mel Duvall, "The Florida Insurance Crisis: Why Are Insurance Companies Leaving Florida?" Insurance.com, December 20, 2023, https://www.insurance.com/home-and-renters-insurance/home-insurers-leaving-florida; and Michael R. Blood, "California Insurance Market Rattled by Withdrawal of Major Companies," *AP News*, June 5, 2023, https://apnews.com/article/california-wildfire-insurance-e31befoed7eeddcde096a5b8f2c1768f.

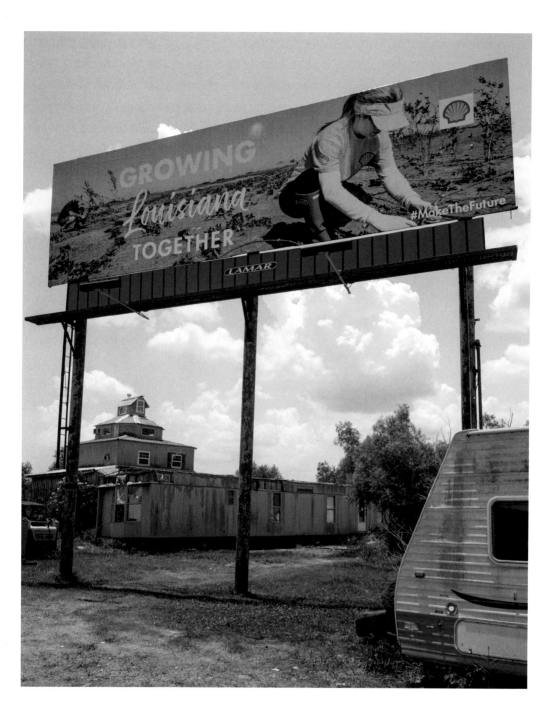

Shell Billboard, Highway 90, Des Allemands, 2023

Devil's Bargain
Michael Esealuka

There is no way to describe the aftermath of a hurricane.
Beyond the physical devastation of the built and natural environment,
there are immense mental and emotional tolls imposed upon
families who've suddenly lost everything – photographs,

baby clothes, family heirlooms. With little warning, generations of memories are swept away in the storm surge. You have to see with your own eyes to understand how a hurricane can break down every system we've come to rely on: commerce and communication, food and water distribution, power grids, and even networks of friends and family.

After Hurricane Ida in August 2021, the power was down in my neighborhood for three and a half weeks. We slept and rose with the sun. For weeks I survived on powdered Gatorade mixed in free bottled water, MREs, and gas station fried chicken.[1] Fresh vegetables and fuel were a luxury. Every gas station south of Baton Rouge had a four-hour line wrapped around the block or running down the highway. That first week after the storm, I made a two-hour roundtrip to coastal Mississippi every day just to fill up my tank and grab supplies for my neighbors. As soon as the streets were cleared enough to come home, I hauled a generator back with me in the bed of my '97 Hardbody down the Mississippi River, from Memphis to New Orleans.

With the generator powering only the essentials, there was no electricity to run our air-conditioning after the storm, and it was hotter inside than out. We hung out on the porch fanning ourselves, mumbling curses to the dog days of summer as we waved away mosquitos buzzing in the thick, languid air. When the sun began to set, the city streets went quiet, pitch-black. The low hum of generators lulled us to sleep.

In many rural communities of Southeast Louisiana where Ida made direct landfall, the government showed up too late, if they showed up at all. The first wave of relief was almost entirely organized by community members and volunteers. Thousands of homes needed gutting or the protection of roof tarps. Elders and small children needed cooling centers and safe drinking water. We were all volunteers spurred into action by climate grief and a deep sense of commitment to our communities. We saw that there was work to be done. No one would come and do it for us. So, we started cleaning up.

We can only do so much, though, in the face of oil and gas commerce. Thousands of wells have been drilled and pipeline canals dredged through our wetlands, tearing apart our fragile coast and leaving our communities increasingly vulnerable to flooding, storms, and coastal land loss. Industry has whittled away at the marsh barrier

that protects us from storms – four major hurricanes have made landfall in Louisiana in the past three years alone. Hit by unpredictable flash floods and escalating hurricanes, as well as tornadoes and wildfires (once unheard of in the Bayou State), we are losing land faster than anywhere in North America. This is the devil's bargain our leaders have made with oil and gas.

As the third-largest energy producer in the US, our state doubles as the national epicenter of oil and gas extraction, refining, and transport. Cancer Alley alone, the 85-mile stretch of land along the Mississippi River between Baton Rouge and New Orleans, hosts over 150 chemical plants, refineries, and other industrial facilities. Over the years, through our generous Industrial Tax Exemption Program and other state incentives, Louisiana has lost hundreds of billions of dollars in potential tax revenue to these large oil and gas companies. In St. John the Baptist Parish, just one facility – the Marathon Garyville Refinery – has received over $10 billion in tax cuts, while the parish has been forced to shutter local elementary schools and post offices.

The story is similar just upriver in St. James Parish. The parish council allowed Americas Styrenics to purchase a post office and Koch Methanol to acquire the only high school in the parish's majority-Black Fifth District. In the face of escalating climate disaster and the ever-rising cost of homeowner's insurance, it is increasingly difficult for families to stay in South Louisiana, while more and more land becomes available for petrochemical expansion.

My friend James, who worked at Citgo for ten years, calls oil and gas our "golden handcuffs." As a young, working-class person in Louisiana, you get your choice of employment: work at a gas station, a refinery, or on the rig. Industry workers sacrifice their health and safety, time with family, even years off their life. Yes, you can make a good living in the industry – it's hazard pay.

Industry has brought wealth for some, but it's taken far more than what it's given back to our state. Every storm lays this truth bare. Driving out along Highway 90 or down the River Road, you see miles of empty sugarcane fields, massive industrial facilities burning off excess toxins in the open air, and trailer homes with faded blue tarps hanging askance off tattered roofs, all remnants from a storm that hit two years ago. Occasionally this scene is interspersed with billboard propaganda: Shell is

"the rhythm of Louisiana" or "Dow Chemical celebrates its 70-year history in our state."

As climate change leads to more frequent and deadly hurricanes, everyone in South Louisiana knows that push will one day come to shove. Louisiana is a place of contradictions. One day the economic logic we've adhered to for so long, industry above all else, will fuel its own collapse.

1 An MRE, or Meal, Ready-to-Eat, is a typical food ration consumed by military personnel and is often distributed to survivors in disaster-stricken areas.

Cypress Museum, Pierre Part, 2018

Six Months after Hurricane Ida, Grand Isle, 2022

Raised House in Plaquemines Parish Near Buras, 2023

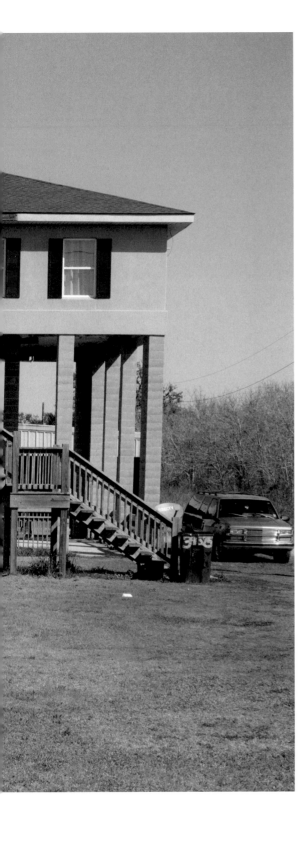

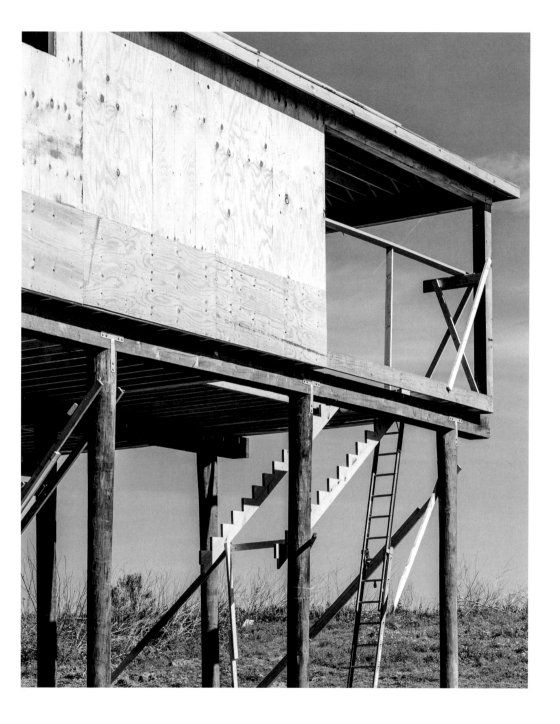

New Construction, Grand Isle, 2020

Collective Failure, Individualized Risk
Rebecca Elliott

 In the context of existing natural hazards policy, a floodplain house elevated multiple stories in the air is considered a success. With their feet and belongings remaining dry as water flows and rises beneath their house, the owner is less likely to suffer a loss when the next storm and flood hits.

The owner will also have saved themselves money – potentially thousands of dollars per year – on flood insurance. The National Flood Insurance Program (NFIP), a public insurance program run by the Federal Emergency Management Agency (FEMA) that provides the majority of flood insurance coverage for American homes, rewards homeowners who mitigate their property-level risk with lower annual premiums. NFIP incentives make elevating a home an economically rational thing to do: the high costs of undertaking such a project are recouped after years of avoided premiums. A lower-risk, affordably insured home is also a sellable one; risk mitigation protects property values. Flood insurance in the United States is structured to require this kind of individual risk management.

But a floodplain house elevated multiple stories in the air is also a failure. Any individual's flood risk, which they are tasked with understanding and mitigating, is the product of decisions that predate and transcend them. It is in fact rather nonsensical to talk about "individual" flood risk, as though it is something that can be apportioned and privately owned.

That houses are still being built in floodplains is the product of planning failures, driven by local needs for continued economic growth and public revenue arrangements that rely heavily on value-assessed property taxes. Communities feel pressure to keep building taxable property, even in risky areas, to generate the funds to pay for schools, libraries, buses, firefighters, and other public goods. That growth imperative ultimately aligns with the interests of the immensely powerful real estate and finance industries, who build in harm's way and reap the profits while leaving the risk to residents. The NFIP itself is also part of this story. It has failed to enforce local land use provisions that were meant to be a condition of participating in the program. When it was established by Congress in 1968, the NFIP was expected to gradually direct development *away* from the floodplains. Instead, the numbers of properties and people at risk of serious flooding have only grown.[1]

That an individual would be in a position to defend a floodplain property is a failure of American social provision. Homeownership is part of the American dream and owning private property – property that grows in value over time, no less – is how individuals are expected to secure their and their families' economic well-being. Homes are important assets and when they are destroyed, or their value

collapses, it can be financially ruinous, as well as emotionally and socially devastating. Without a more tightly woven safety net, it is no wonder that people must go to strenuous lengths to protect their investments.

That only some people are able to elevate their homes is a failure of equity. An individualized strategy of risk management relies on individual capabilities that vary along racialized socioeconomic lines. Some people can absorb increases to flood insurance rates; for others, those increases make it impossible to comply with their mortgage requirements, effectively pricing them out of their homes. Some people can access capital relatively easily to make significant risk-mitigating improvements to their homes; others will go deep into debt and compound their economic hardship. Some people have the resources to move to higher ground should they ultimately decide to do so; others are stuck in place, feeling the effects of a more general housing affordability crisis, which makes it hard for owners, renters, and tenants alike to find decent, safe housing elsewhere. The ability to participate in homeownership, as well as the benefits of it, have always been unequally distributed. The economic rationality of flood insurance will be felt most coercively and punitively by people and communities of color for whom racist housing policy and real estate practices have perpetuated economic marginalization.[2]

That homeowners are paying today for risks that are only intensifying marks a failure by governments to respond to the climate emergency. We have known for decades about the loss and damage that climate change portends. We have observed sea level rise and we are already seeing the effects of climate change like extreme weather. One powerful way to address flood risk, and its escalating costs, would be to mitigate the factors contributing to it by decarbonizing the economy and transitioning off fossil fuels. Without significant progress here, we leave homeowners shouldering the costs of that failure.

An individualized approach to risk management, structured by flood insurance arrangements, leaves the question of how to live with water increasingly at our doorsteps. But floods are shared calamities and flood risk is collectively produced. This raises more, and potentially more difficult, questions: How will we live together, and what do we owe each other, in a wetter world?

1 Recent studies demonstrate that the number of properties below sea level or in floodplains have continued to rise over the past thirty years. They also show there is a correlation between increased flood risk and displacement, with Black residents in coastal communities among the most affected. See James G. Titus, "Population in Floodplains or Close to Sea Level Increased in US but Declined in Some Counties – Especially among Black Residents," *Environmental Research Letters* 18, no.3 (2023): 034001, https://doi.org/10.1088/1748-9326/acadf5.

2 For more on the racial origins and ramifications of these housing models, see Keeanga-Yamahtta Taylor, *Race for Profit: How Banks and the Real Estate Industry Undermined Black Homeownership* (Chapel Hill, NC: University of North Carolina Press, 2019); Elizabeth Korver-Glenn, *Race Brokers: Housing Markets and Segregation in 21st Century Urban America* (Oxford: Oxford University Press, 2021); Dalton Conley, *Being Black, Living in the Red: Race, Wealth, and Social Policy in America* (Oakland, CA: University of California Press, 2009); David M. P. Freund, *Colored Property: State Policy and White Racial Politics in Suburban America* (Chicago: University of Chicago Press, 2007); Richard Rothstein, *The Color of Law: A Forgotten History of How Our Government Segregated America* (New York: Liveright, 2017).

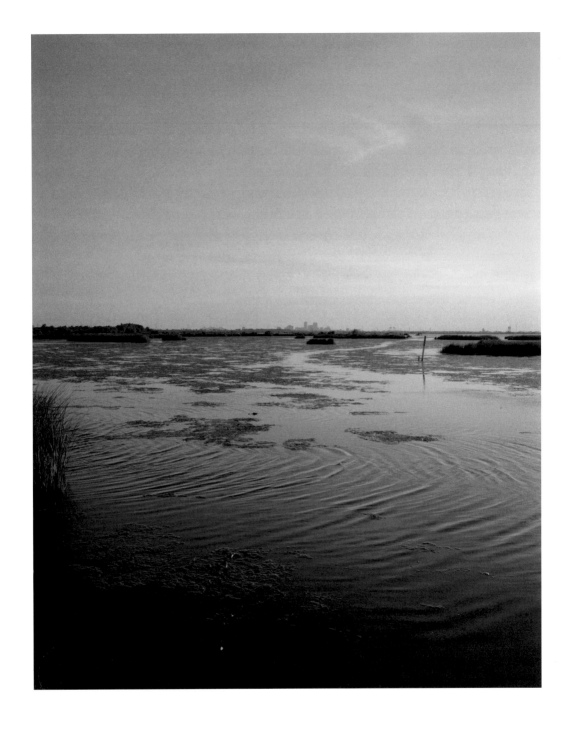

Bayou Bienvenue and the New Orleans Skyline from Paris Road, 2020

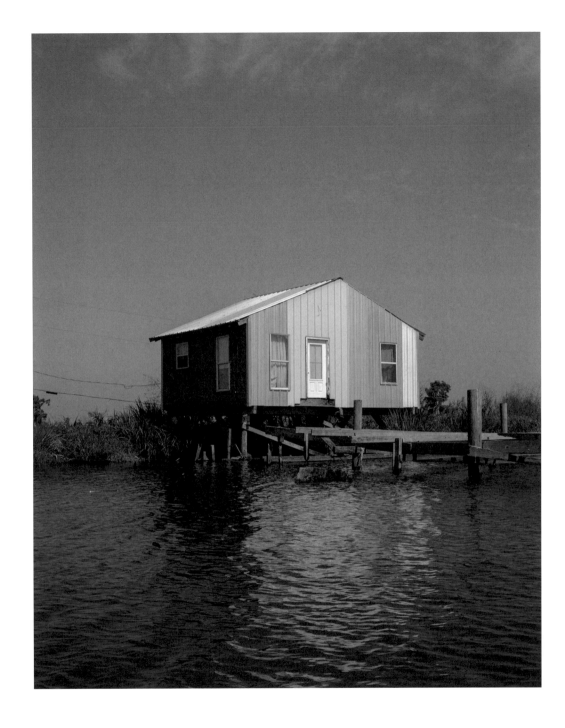

Camp on Lake Maurepas, 2021

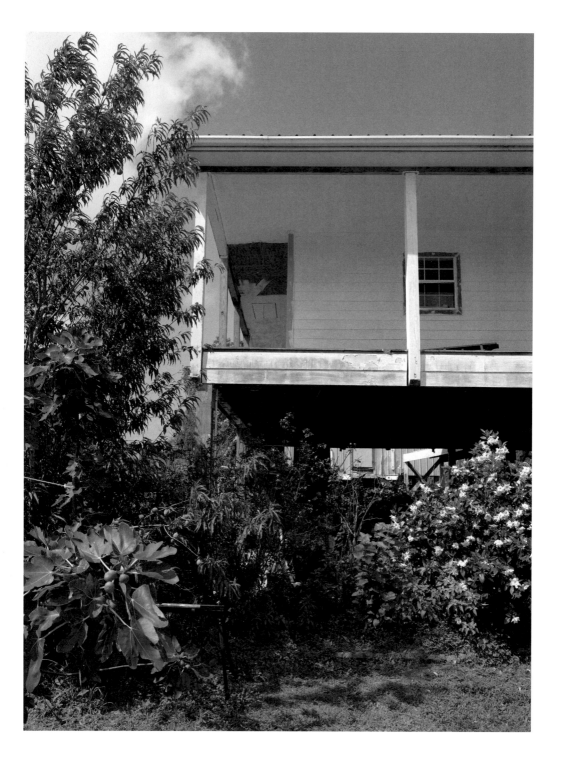

John and Bernita's House NO.1, Montegut, 2023

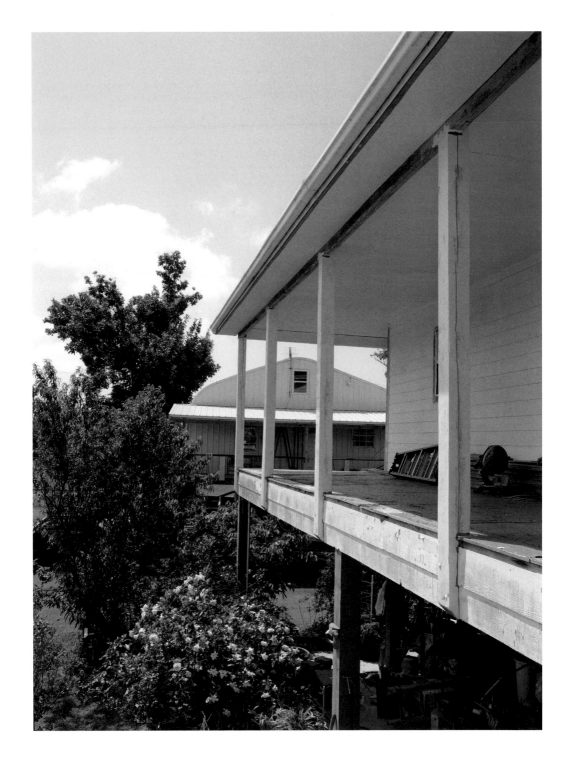

John and Bernita's House NO.2, *Montegut, 2023*

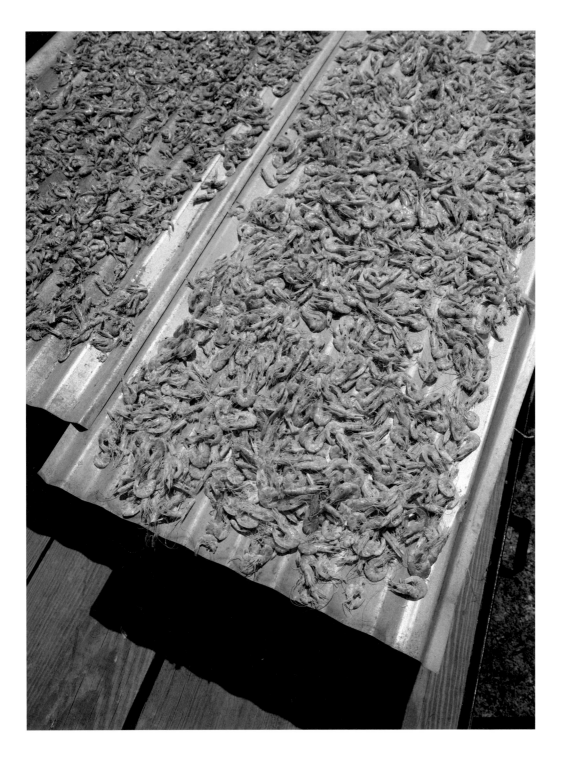

Drying Shrimp, Montegut, 2023

A Conversation with John Verdin

 The boundaries of John and Bernita Verdin's home, like most properties in lower Terrebonne Parish, are delimited by different bodies of water. Their house in Montegut

on Route 665 runs parallel to Bayou Pointe au Chien, with a government-built back levee constructed behind their vegetable garden to mitigate the impacts of storm surge flooding. Terrebonne Parish's name is derived from the French phrase *terre bonne*, meaning "good land."

I met with John and Bernita in May 2023 to talk about their time living and working with this land and their recovery process after Hurricane Ida. The following are excerpts from our conversation.

 —Virginia Hanusik

*

VIRGINIA HANUSIK Have you always lived in Montegut?

> JOHN VERDIN We've been over here about twenty-five years… We used to live further down the road.

VH And was the house always raised like this?

> JV No, it was raised but not this high. It was about 8 feet up I believe. I think we're 15 feet high right now.

*

JV I was in the business of raising houses a few years ago.

> VH When do you feel like business first picked up? Or has it always been in demand? 142

jv No, it was right after Rita and Katrina. Katrina didn't do no damage here really, but Rita did. Everybody was flooded. We had 6 feet of water right here. After Rita, everybody wanted to raise their houses. So, we raised houses for a while.

vh Do you still do that?

jv No, no. We all gave that up because the big companies came in the picture and we couldn't compete with them.

*

vh Do you ever feel like your neighbors won't want to put up with another storm, that they're going to leave?

jv I don't think so. Wherever you go, you know, you'll get hit with something. If it's not a flood, it'll be a tornado or a fire. There's a family with a house a ways down this little road. They got a lot of damage from the storm and some of their relatives came and helped them. They said, "But why don't you just leave?" He told them, "I chose to come over here. I'm not going to leave. This is where I want to live." So you rebuild and move back in. And a lot of people feel like that, you know? I know I feel like that. I wouldn't leave.

Lake St. Catherine, Orleans Parish, 2023

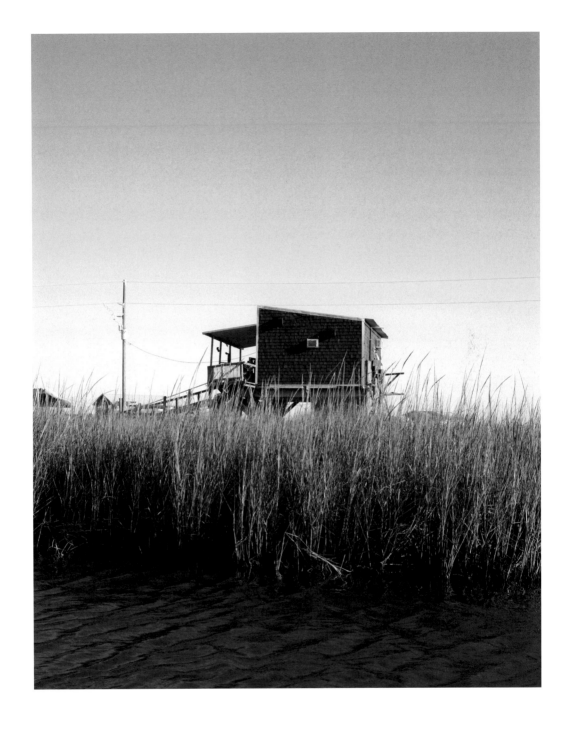

Marsh Near Grand Bayou Village, Plaquemines Parish, 2020

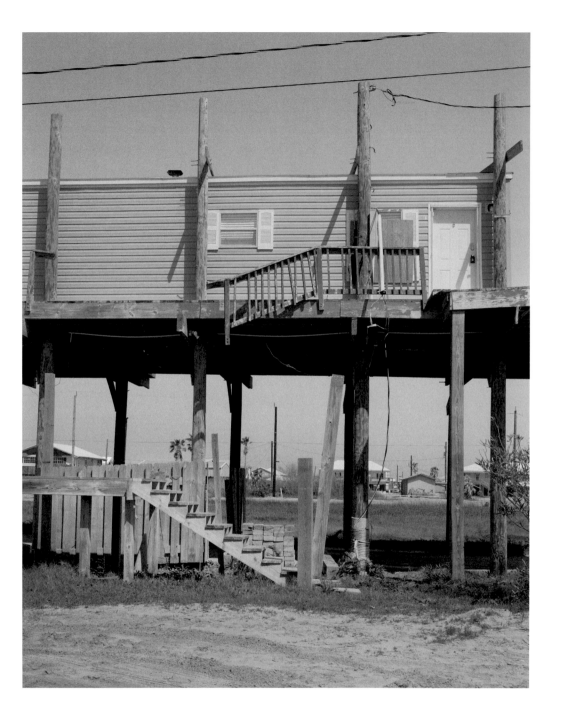

Grand Isle Six Months after Hurricane Ida, 2022

Living, Not Just Surviving
Jonathan Tate

What southeastern Louisiana offers its people, in addition to its natural abundance, is a myriad of ways to live on its land. It is necessary to foreground that this is forsaken land – although not for the people who live here – that it is undeniable what years of taking –

most harmfully by those of us who *don't* live here – has done; and what this abuse portends for its future. Adaptation and decline have consequently been interwoven into the fabric of the buildings that dot this landscape. This is how its history is being written in real time.

Some of this is obvious. In a coastal landscape, the relationship to the ground is always tenuous. In southeastern Louisiana, most buildings are nominally elevated, though some extremely so, on what can seem like a forest of timber piles, or poles, driven into the earth. Some are constructed this way from the beginning, intuitively perhaps; others are subsequently elevated through a process of retrofitting that is now routine. Town structures, main streets, on the other hand, are still grounded. But that's how they came to be, originating in a time when the environmental conditions we're now familiar with were inconceivable. There's a range of in-between landscapes, but the closer you get to the coast, the more your relationship to the ground is exaggerated. Buildings are lifted to dramatic heights, clearly reflecting the certainty of flooding and land loss. Roadways sit barely above the top of the water, further illuminating the precarity of living and existing in this environ- ment. These variations evidence that there is no consistent, or recognized, standard determining a uniform elevation – no stable waterline that affects all equally. Rather, geographic positioning, social and economic status, and infrastructural proximities all establish a variable range of habitation.

In addition to the configuration of one's building foundation, a rich and diverse culture tied to this environment is often just as exposed. Life and livelihoods are expressed through the artifacts you see embedded within the land and attached to buildings. Nets, crab cages, and boats of all types are abundant here. They suggest one's part in the workings of this place. Is it leisure? Is it an active role in the economy of the region? Are you a rig worker, a boat hand, or part of a fishing camp for weekenders? The manicured anonymity you often find in American suburbs seems absent here. There's a particular intimacy and ingenuity evident in these displays; they express the material necessities of an active participation in the ecology of a place – an apparent desire to exist within this landscape. Most of it is quite beautiful.

If one looks closer and with some care at the efforts involved in living here, it's possible to sense a more nuanced understanding of the regional environment. There is a temporal

relationship with water that is manifest in the built condition. We see this through the patchwork of adaptive alterations common to so many buildings in southeastern Louisiana's coastal regions. There are the successive additions to stairs, to lengthen runs from a raised floor to a shifting ground. These are rendered in materials that speak to their age: precast concrete – no longer easily available but once widely used – often forms a base; and a series of extensions constructed in treated lumber – the oldest of which are long-grayed now, curling and split, with fasteners struggling to maintain their connections and the newest of which are still green with preservative. Then, again, there are the raised timber pile foundations, where sometimes they appear consistent with the age of a home and at other times it's evident they are responsive, put in place to raise – or even further raise – a structure, resulting in jarring connections between the original ground-level edge of a building and its new supports.

The water encroaches on these sites as the land erodes. Water is rising with each coming year. And water comes in torrents at any moment. This dynamism creates ruptures and breaks. It changes the way we exist. And that way of living telegraphs a mentality attuned to cataclysmic events, some slow moving, some abrupt and jarring.

Just like the water, the built environment is in constant flux. Changes, modifications, and adaptations all happen as routine or as a course of one's daily life. Nothing, built or natural, stays the same for long. There's an orchestration of life and environment writ in the manipulation of structure and ground. This is often subtle – like the ubiquitous added stair tread and riser – but other times extreme. In the latter case, in the levees and storm barriers, it's the fractures, when there's an indication of abrupt change, that jars our view of this world. Plasticity has its limits. Building has limits. And people do, too.

But ingenuity – how to live, not just survive, as individuals and a community – and care – for what one has and has by way of living here – appears limitless. Despite forces even larger than the scale of this vast landscape, the endless work goes on to maintain the built environment. These efforts, made in place of simple abandonment, acknowledge the importance of this place to a community unwilling to accept it as forsaken. Their lives are transcribed in what they've made here, how they've remade it, and how they continue to do so.

But despite this commitment, if we do ultimately believe architecture is emblematic of societies, this is not a history that will likely be legible in the future. At least not in the normative way one sees history in architecture as a participant of a living, built environment. The way things are going, this remarkable built environment, capable of reflecting a rich, diverse culture – a unique way of life – and generations of work will, inevitably, be lost to the water.

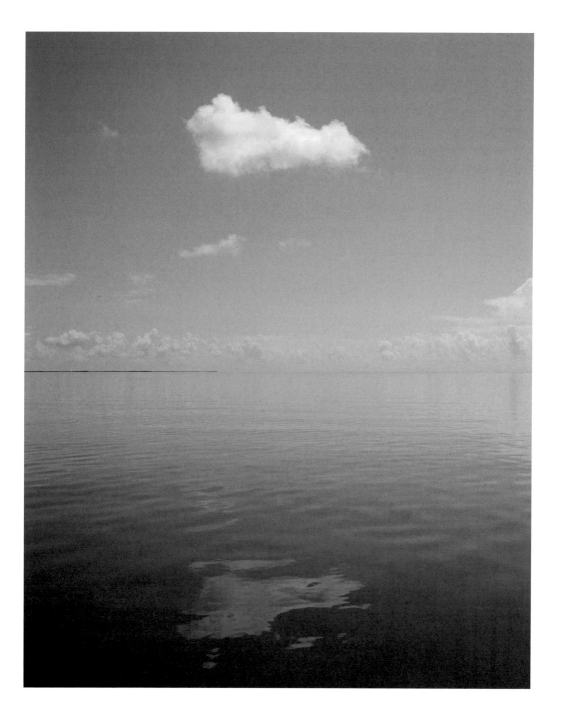

Former Marsh Near Point a la Hache, Plaquemines Parish, 2021

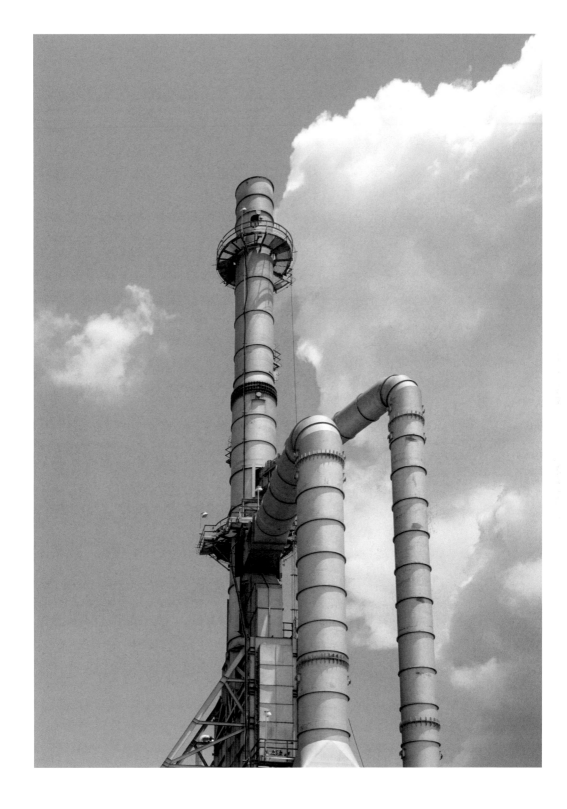

Valero Refinery, Norco, 2020

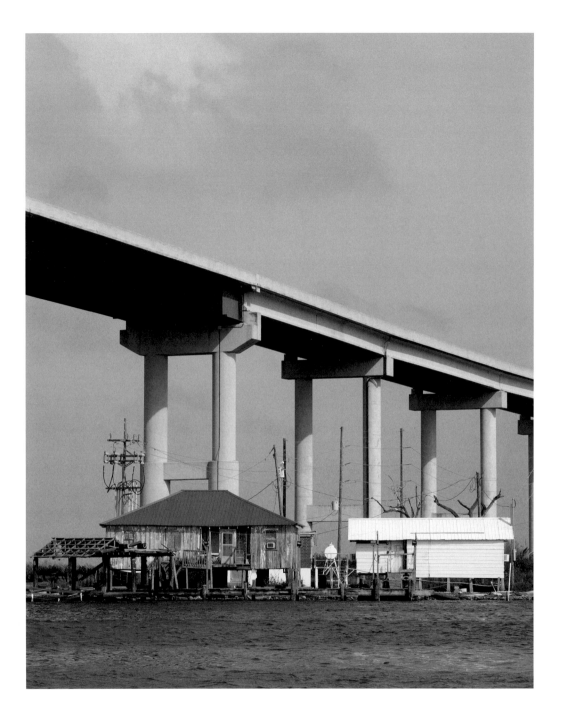

Elevated Route 1 over Leeville, 2021

Returning to the Water
Jessi Parfait

 A little more than 10 miles from the southern most point of
Lafourche Parish stands Leeville, a once-thriving coastal community.
Originally named Orange City for its orchards, Leeville was first
established by the survivors of the hurricane that hit the

community of Cheniere Caminada in 1893 – the deadliest storm in Louisiana history. According to newspapers from the time, the first half of the storm hit with minimal damage. The eye of the storm lingered though, creating a sense of false calm and safety that lured people out of their shelters. Soon after, the winds shifted and the storm pulled a massive tidal wave ashore, killing an estimated 2,000 people. Today, 130 years later, it is still the deadliest storm in Louisiana history. Those who survived moved further inland – or "up the bayou" as we like to say – as many coastal communities still do today and as my own family did after Hurricane Andrew in 1992. We seek safety but try not to stray too far.

By 1905, Leeville had an estimated 1,500 inhabitants, all of whom were relatively self-sufficient. The fertile land with nearby freshwater lakes provided an abundance of seafood, furs, cotton, rice, and grapes. But other than the contact they made when selling seafood to the New Orleans French Market, the community was isolated by its remote location so far south. Tragedy struck again in 1909 when another hurricane flooded Leeville with 3 feet of water, but this time, by all accounts, all lives were spared but one. In 1915, Leeville weathered yet another devastating hurricane when waters flooded in excess of 14 feet. Oral histories tell of families resettling up the bayou in Golden Meadow in the wake of the storm. Some allegedly built their new homes with the same lumber carried over from their original homes in Cheniere Caminada.

As if the surviving people of Leeville had not endured enough, the oil and gas industry moved into Lafourche Parish in the 1930s. Canals, required to navigate and transport equipment, cut up the landscape surrounding what was left of the community. In addition to destroying the land, canals destroyed the marsh by connecting fresh-water areas to saltwater sources, which kills vegetation. Oil fields were constructed in the areas surrounding Leeville, and the early days of this exploration often resulted in oil spills, which has also killed the surrounding marsh. As anyone who lives in coastal Louisiana will tell you, our natural wetlands are not just a home for alligators, they are our best defense against coastal storms. They absorb storm surges before they make it to our communities. Additionally, extraction is linked to local subsidence, the gradual sinking of our land. Research shows that the wetlands around Leeville are sinking by as much as 30 inches every month.

What remains of Leeville is slowly slipping into the murky waters. The concrete covers of tombstones are now leaning on the banks, waiting to be reclaimed. What is left of Leeville will soon join the Cheniere Caminada, and as I witness it, I cannot help but wonder how much longer it will be until my coastal community of Houma, and all others like it, meet the same fate.

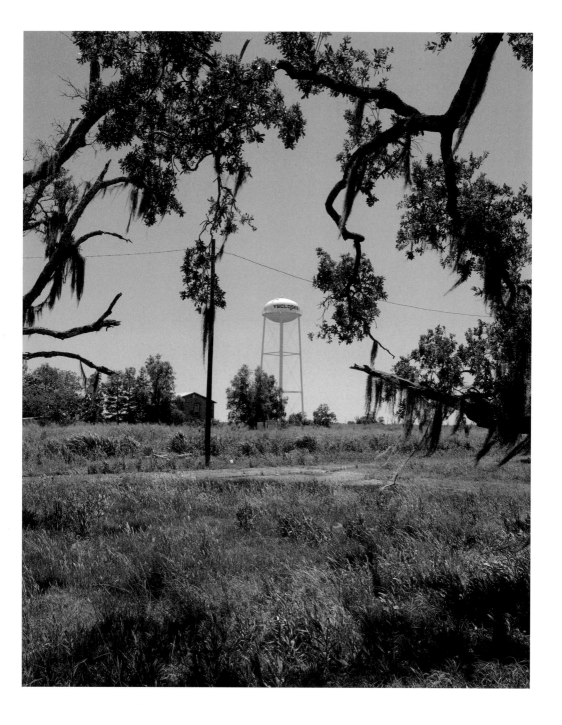

Yscloskey Water Tower, St. Bernard Parish, 2023

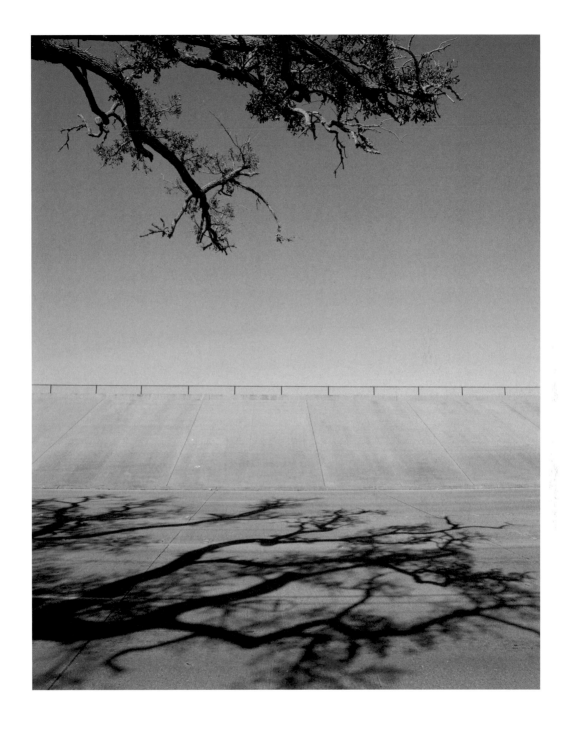

Lake Pontchartrain Levee on Hayne Boulevard, New Orleans East, 2019

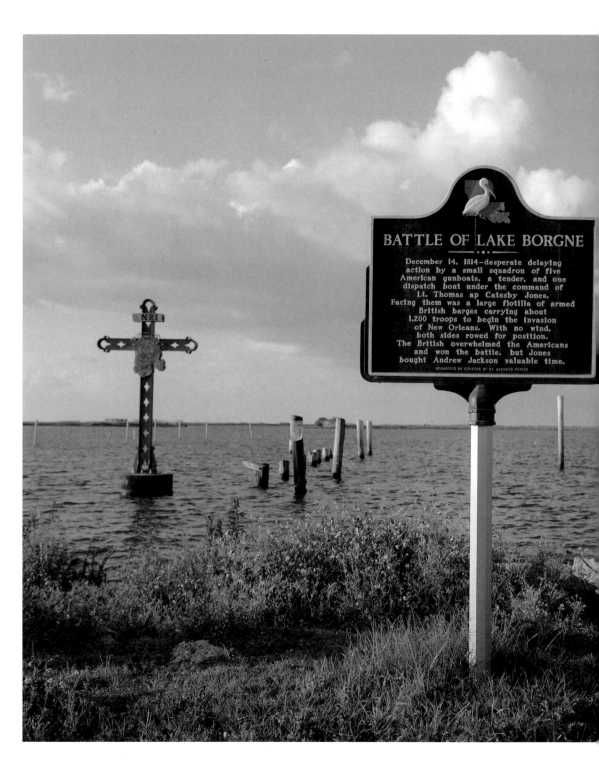

Mississippi River-Gulf Outlet, Shell Beach, 2023

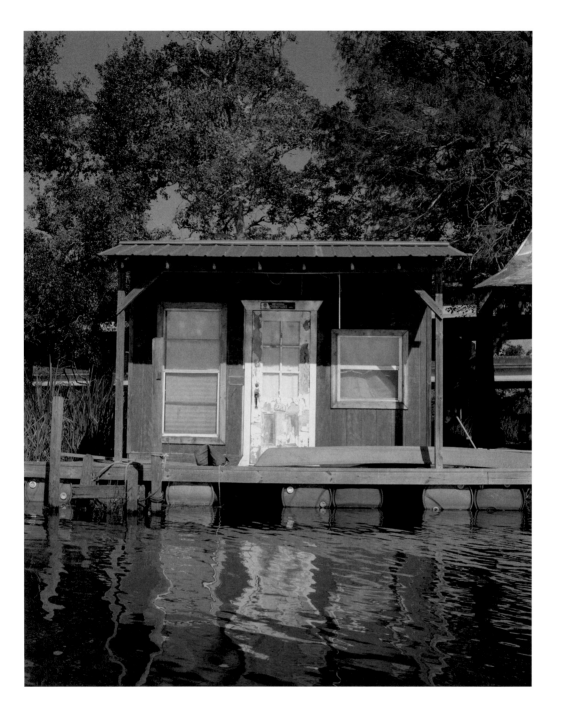

Houseboat on Lake Maurepas, 2022

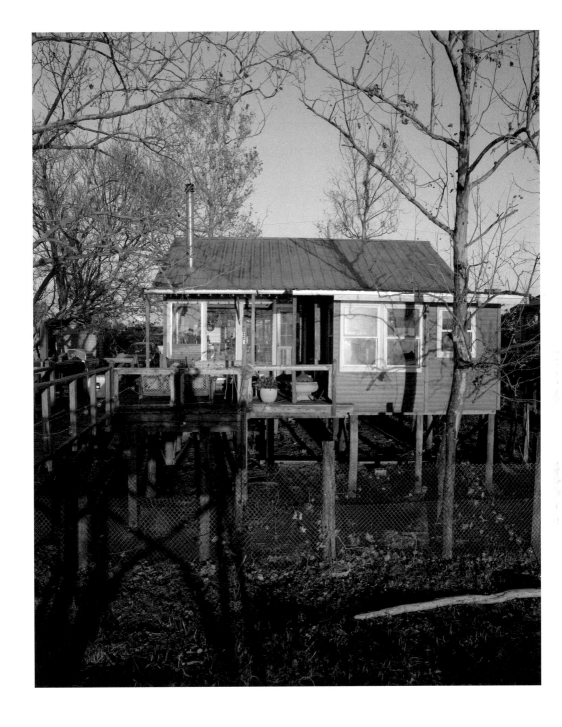

Batture House, Jefferson Parish, 2022

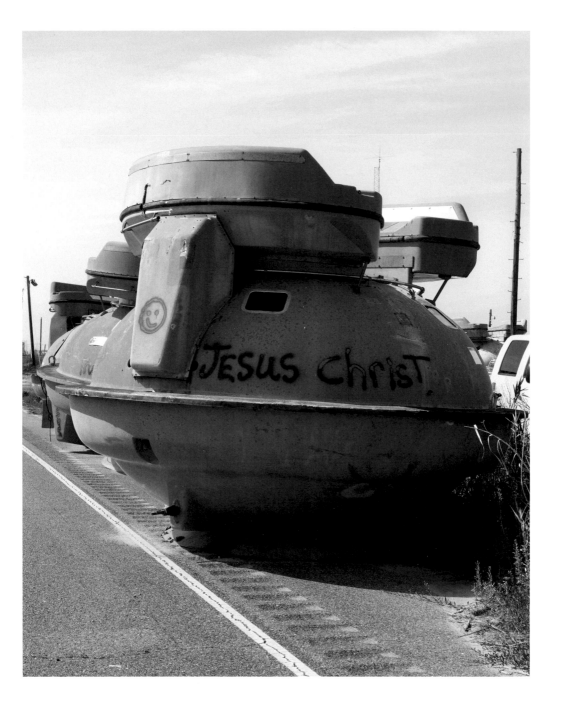

Emergency Vessel on Old Route 1, Leeville, 2020

Raccourcis / Shortcuts
Louis Michot

 Au secours, au secours!
 Mais pas aux séjours
 Qu'on ira passer notre temps
 Après espérer pour les autres

De penser à notre bien
À notre bonheur

Chaque jour c'est
une bénédiction
Une autre journée
plus près du paradis
Si on croit que
notre vie sur la terre
C'est pas le
paradis même

Équand on va voir
Que notre vie c'est pas la course
Qu'il y a pas de sauvetage
Qu'il y a pas de paradis

Sauf qu'ici, asteur
Équand on va arrêter
De jouer aux cartes avec
Ce que le Bon Dieu nous a donné

Équand on va
a prendre la
décision
De soigner
notre bien
Comme si
l'ouvrage
était fait
Pour améliorer
la qualité
de nos jours

Y'a pas de sauvetage
Pour un pays
Qu'etait coupé
À faire des raccourcis

Pour gagner une piastre vite
En espèrant de vivre aux séjours
On a fait un pari
Et on a perdu

Jésus Christ, pardonne

166

nos péchés
Et sauver nous de notre avidité
Sans bateaux, sans miracles
Qu'on peut sortir de ton chemin

Et laisser les rivières
Remplir nos verres
Et rebâtir la terre
Ici dans le paradis

Help! Help!
We can't stay here

Passing our time
Waiting for someone else

To think of our well-being
And our happiness

Every day is a blessing
Another day closer to heaven
If we believe that our life on Earth
Isn't heaven itself

And when will
we see
That life isn't a race
That there's no
saving us
That there's no
paradise

Except here, now
And when will we stop
Playing cards
With what God gave us

When the decision is made
To take care of our own well-being
As if the work is all done
To improve our quality of life

There is no savior,
no vessel
For a land
That was cut
To make shortcuts

To make a quick dollar
Hoping to live on vacation
We made a bet
And we lost

Jesus Christ, forgive our sins
And save us from our greed
No boat, no miracles
Let's get out the way

And let the rivers
Fill our cups
Rebuild our land
Here in paradise

Fishing Lines on Tide Water Road, Venice, 2020

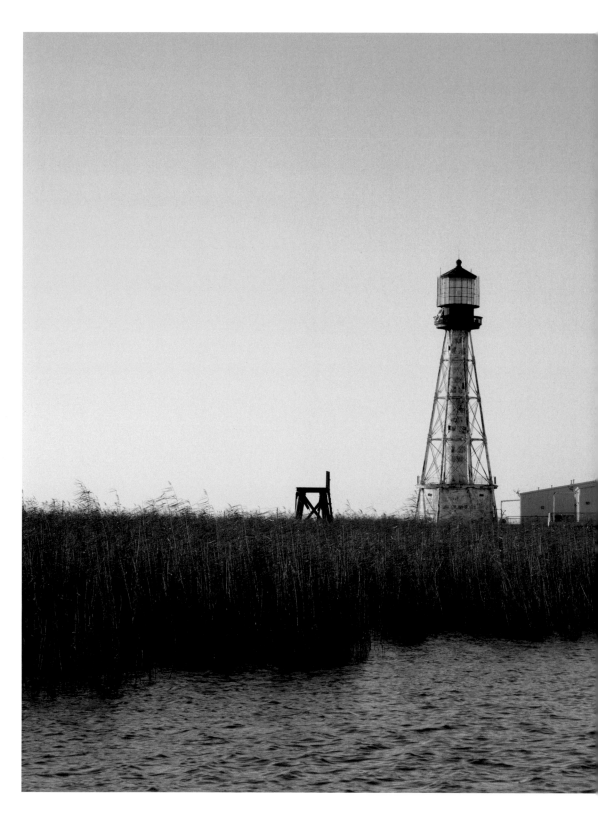

Port Eads Lighthouse, Plaquemines Parish, 2020

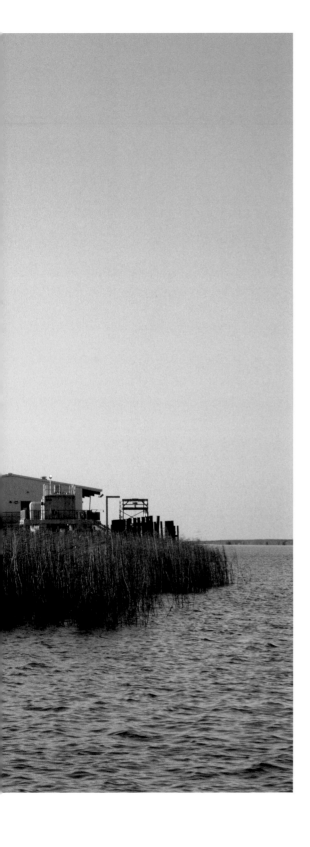

Acknowledgments

This book is a product of so many people. First, I would like to thank my brilliant editors and the rest of the team at Columbia Books on Architecture and the City. Joanna Joseph, Meriam Soltan, and Isabelle Kirkham-Lewitt got this book across the finish line with their feedback, patience, and critical eyes. Thank you to the New Information team, especially David Yun and Inyeong Cho, whose expert advice and vision brought this material to life.

I am deeply and forever grateful for the contributors whose words populate these pages and who trusted my photographs to be seen alongside their stories. Richie Blink, Imani Jacqueline Brown, Jessica Dandridge, Rebecca Elliott, Michael Esealuka, T. Mayheart Dardar, Billy Fleming, Andy Horowitz, Arthur Johnson, Louis Michot, Nini Nguyen, Kate Orff, Jessi Parfait, Amy Stelly, Jonathan Tate, and Aaron Turner: thank you for making this book what it is. Thank you to John and Bernita Verdin for sharing your home and stories with me. A special thank you to Kate for planting the seeds for this publication many years ago and whose belief in this work has always motivated me. Thank you to Andy and Billy for being mentors to me through this process and beyond.

Were I to list everyone in Louisiana who has helped and inspired me in various ways over the past ten years, this acknowledgments section would exceed the page count of the book's content. I am forever indebted to the people of New Orleans and South Louisiana who welcomed me when I first arrived and when I found my way back. This book is an attempt to demonstrate the deep love and respect I have for you and your generosity, which I have never taken for granted.

Thank you to the very special people at A Studio in the Woods, the bottomland hardwood forest by the river that will remain one of the most enriching and affirming experiences of my time making art. Ama Rogan, Cammie Hill-Prewitt, and Grace Rennie, thank you for your care and relentless support of all the creative energy that the studio has inspired. Thank you to Joe Carmichael who brought us all together and whose spirit lives on in those woods.

A project of this size was conceived and produced in phases, and I am deeply

grateful for the individuals who have supported my growth, encouraged and challenged my vision, and whose influence will forever stay with me. Thank you to Paul Marienthal for your continued guidance in life. Thank you to Stephen Shore and An-My Lê for introducing me to photography and to the many ways of seeing. I am so grateful to have taken an art history class taught by Julia Rosenbaum, which shaped the course of my career, and I thank her immensely for her mentorship, friendship, and for reading an early draft of this book.

The beginning of this project was heavily influenced by the work of Arlie Russell Hochschild and I am so thankful for her generosity and the conversation we shared many years ago in the Berkeley Hills.

Thank you to the people and institutions who have supported my work in Louisiana through funding and exhibitions over the last several years: Iker Gil at MAS Context; Mimi Zeiger, Anne Surak, Catherine Seavitt Nordenson, James Pike at the Graham Foundation; along with the Pulitzer Center, the Andy Warhol Foundation for the Visual Arts, the McHarg Center, and the Front Gallery.

The following friends and colleagues made substantial contributions to the development of this project with their words, energy, support, and wisdom, and I thank them for teaching me more than they know:

Rebecca Atkinson, Robert Baddour, Estefania Barajas, Nathan Birnbaum, Chris Buonanno, Richard Campanella, Aron Chang, Steve Cochran, Milan Daemgen, Patrick Daurio, Gregory Farley, Lisa Frederickson, Catherine Gans, Lauren Gauthier, Max Gavrich, Kai Germano, Hannah Hayes, Lt. Gen. Russel Honoré, Melissa Jarrett, Anna Kline, Raquel Kraushar, David Lopez, Leonardo Leiva Rivera, Fred Rhoads, Remy Robert, Sosha Mathew, Rajasri Narasiman, Meshell Ndegeocello, Lucy Satzewich, Elisa Speranza, Saegan Swanson, Will Tilghman, Carlos Torres de Janon, Sean Tucker, TraciAmanda Washington, Carl Joe Williams, Scott Wood, David Yancey, and many others that I regret spatial constraints prevent me from mentioning but who I am so grateful for.

A very special thank you to Zora Bowman, Marguerite Lloyd, Megan Smillie, Alyssa Murphy, and Erik Paskewich for being alongside me through so many chapters, of my own and of this book.

And, lastly, with the weight of all this supported by them, I'd like to thank my family, for whom my presence in and curiosity of this world could not exist without. To my grandparents Jean and Alan Hanusik and John and Virginia Fusaro, to my Aunt Alane, to my brother, Russell, for your unwavering kindness and your empathic nature, and to my parents, Donna and Barry, for believing in me and being the love that makes anything worth doing. I couldn't have made this without you.

Richie Blink
has spent a lifetime on the bayous of Louisiana studying its wetlands, people, and economy. Richie has organized grassroots coastal restoration projects between his hitches as an oil field boat captain in the Mississippi River Delta and is now responsible for the planting of 35,000 trees to reduce storm surge near his home south of New Orleans. Recognizing that education is the single most effective tool in keeping the delta functioning, Richie started Delta Discovery Tours in 2015. Since then, thousands of people from around the globe have visited the delta with him on his converted shrimp boat, which he rebuilt from the keel to the mast. He is a founding member of New Harmony High, a game-changing public high school that uses students' passions, talents, and skills to address the coastal changes in Louisiana. In 2019, he was a winner of the Coalition to Restore Coastal Louisiana's Coastal Stewardship Award.

Imani Jacqueline Brown
is an artist, activist, writer, and researcher from New Orleans, based between New Orleans and London. Her work investigates the "continuum of extractivism," which spans from settler-colonial genocide and slavery to fossil fuel production and climate change. In exposing the layers of violence and resistance that form the foundations of settler-colonial society, she creates space to imagine paths to ecological reparations.

Imani combines artistic and archival research, ecological philosophy, legal theory, people's history, and countercartographic strategies to disentangle the spatial logics that make geographies, unmake communities, and break Earth's geology. Her research is disseminated through films and art installations, public actions and performance, and reports and testimony delivered to courts and organs of the United Nations. Her work has been presented internationally, including in the US, the UK, Poland, Germany, and the United Arab Emirates.

Among other things, Imani is currently a PhD candidate in geography at Queen Mary University of London, a research fellow with Forensic Architecture, and an associate lecturer in MA Architecture at the Royal College of Art.

Jessica Dandridge,
as the executive director of the Water Collaborative of Greater New Orleans (TWC), has dedicated her life to community advocacy and campaign development for organizations that seek to be socially, economically, and culturally inclusive. At TWC, she focuses on community-led adaptation and mitigation, the strategies that comprise the core of water justice and climate resiliency. To be resilient, Jessica believes communities need abundant, rapidly distributed resources. To achieve this, Jessica has led a movement that centers water management as a tool for social and economic liberation, which aims to transform Louisiana's most vulnerable communities. Today TWC focuses on water management, hazard mitigation, water justice through accessibility, affordability, quality, and equitable community transformation through blue-collar and green jobs and the renewable energy economy.

Jessica earned a BA in political science from Xavier University of Louisiana and an MA in international affairs with a concentration in conflict and security at the New School for Public Engagement in New York City. Since starting her career as a youth organizer in 2005, she has worked for and collaborated with over two dozen organizations in Greater New Orleans and nationally.

Before starting at the TWC, Jessica was the Louisiana state director at the Campaign Election Engagement Project and a program director of the Rural Electric Cooperative Democracy Project at the Rockefeller Family Fund. Jessica has received certification as a trained facilitator from Youth Program Quality Intervention, has a certificate in leadership, activism and civil rights from Brown University, and a certificate in Kingian nonviolence strategies from the Selma Center for Nonviolence. In her current work, Jessica is the cochair of the National Academies of Science, Engineering, and Medicine's climate resiliency roundtable discussions, a member of the community advisory board for the Coalition to Restore Coastal Louisiana, and is a board member for New Harmony High School in New Orleans. In 2023, Jessica was selected for the 2023 Obama Foundation's Leaders USA cohort, and was selected for *Gambit*'s 2023 "40 Under 40" in the Greater New Orleans region.

T. Mayheart Dardar
was born in Golden Meadow, Louisiana. He is the son of Raymond Mayheart and Elsie Dardar. T. Mayheart spent his childhood and adolescent years trawling and trapping with his father, later working as a crane operator, diesel mechanic, and tankerman.

He is a former member of the United Houma Nation Tribal Council, serving for sixteen years as councilperson, vice-principal chief, and council-appointed tribal historian. He is the author of three books on tribal history and culture, a contributor to three anthologies, and has written numerous articles highlighting Indigenous political philosophy.

Rebecca Elliott
is an associate professor of sociology at the London School of Economics. Her research examines the intersections of environmental change and economic life as they appear across public policy, administrative institutions, and everyday practice. She is the author of *Underwater: Loss, Flood Insurance, and the Moral Economy of Climate Change in the United States* (Columbia University Press, 2021). In addition to publishing in academic journals, she has contributed to the *New York Times*, the *Houston Chronicle*, and *Harper's Magazine*.

Michael Esealuka
is a longtime labor and climate justice organizer based in New Orleans. Working at the inter-section of environmental justice and renewable energy transition, Michael organizes with communities in petrochemical "sacrifice zone" regions – namely the Ohio River Valley and the US Gulf South – as they resist extractive industries and fight for a just, regenerative economy. As a director and producer with Frontline Media Network, Michael also creates short-form video content to elevate critical stories from the Gulf South climate front lines.

Billy Fleming
is the founding Wilks Family director of the Ian L. McHarg Center for Urbanism and Ecology at the University of Pennsylvania's Stuart Weitzman School of Design. He is cofounder of the Climate and Community Project – a climate justice think tank dedicated to

connecting movement demands to progressive legislators via applied research on the built environment; cocreator of the organization Data Refuge – an international consortium of scientists, programmers, archivists, librarians, and activists dedicated to securing critical environmental data at risk of erasure during Donald Trump's administration; and a co-founder of Indivisible – a progressive organizing nonprofit with chapters in every congressional district in the US. His recent work includes *A Blueprint for Coastal Adaptation* (Island Press, 2021), *Design With Nature Now* (Lincoln, 2019), and the digital humanities projects Field Notes Toward an Internationalist Green New Deal and An Atlas for the Green New Deal. His writing has appeared in *Dissent*, the *Guardian*, the *Washington Post*, *Places Journal*, *LA+*, and the *Journal of Architectural Education*, among others. He grew up in the muddy landscapes of the Arkansas River Valley near Fort Smith, Arkansas.

Virginia Hanusik
is an artist whose work explores the relationships between landscape, culture, and the built environment. Her projects have been exhibited internationally and are supported by the Graham Foundation, the Andy Warhol Foundation for the Visual Arts, the Pulitzer Center, and the Mellon Foundation, among others. She writes about landscape representation, extraction, and the visual narratives of climate change. Virginia has been featured in the *New Yorker*, *Oxford American*, the *British Journal of Photography*, and *National Geographic*. She lives in New Orleans.

Andy Horowitz
is an associate professor of history at the University of Connecticut and serves as the Connecticut State Historian. His first book, *Katrina: A History, 1915–2015* (Harvard University Press, 2020), won the Bancroft Prize in American history and diplomacy, and was named Humanities Book of the Year by the Louisiana Endowment for the Humanities and a Best Nonfiction Book of the Year by *Publishers Weekly*. He has published essays in the *Atlantic*, *Time*, the *Boston Globe*, the *Washington Post*, *Rolling Stone*, and the *New York Times*. He was previously an associate professor of history and

the Paul and Debra Gibbons Professor in the School of Liberal Arts at Tulane University in New Orleans.

Arthur Johnson
has held the position of chief executive officer at the Center for Sustainable Engagement and Development (CSED) since 2010, working closely with staff and volunteers to advance CSED's key initiatives, which focus on food security and natural and built environments.

Arthur was born in the Nation's capital but his roots are in New Orleans, where he used to visit his grandmother on Fostall Street in the Lower Ninth Ward. He grew up in Washington, DC, and earned undergraduate and graduate degrees from the George Washington University and the University of the District of Columbia, respectively. He relocated to New Orleans in 1999 where he has established himself as an accomplished fund-raising professional and nonprofit leader with a number of educational institutions and nonprofit organizations. This has included work with Tulane and Xavier Universities and NOLA Public Schools.

More recently he has served as regional vice president for Major Gifts at the American Heart Association, director of the Office of Development for Episcopal Community Services of Louisiana, and chief development officer for Operation Reach. He has served on the board of New Harmony High School, a state charter school focused on environment and resilience, providing opportunities for young people to explore and developing young minds and leaders of the future. Arthur was selected as the winner of the 2019 Paul and Joyce Aicher Leadership in Democracy Award. Most recently, he has been appointed to the 2023 Governor's Advisory Commission on Coastal Protection, Restoration and Conservation.

Louis Michot
is a Grammy Award–winning fiddle player and singer for Lost Bayou Ramblers. He released his debut solo album, *Rêve de Troubadour*, in 2023. In 2018, Louis founded Nouveau Electric Records, which promotes experimental and traditional music that incorporates Louisiana French. Louis was named Louisianian of the Year in 2020

alongside his brother, Andre. That same year, he began incorporating solar technology into his music operations with a solar-powered studio and mobile solar music stage dubbed the "Solar Roller." This work also informed his hurricane relief work, as noted in the *Rolling Stone* article "Can This Cajun-Punk Musician Protect His Culture From Climate Change?" Louis worked on raising funds to procure solar generators and panels for residents of Terrebonne Parish affected by Hurricane Ida, which was detailed in the *New Yorker* article "The Lost Bayou Ramblers Get Lit."

Nini Nguyen
is a New Orleans-based chef, instructor, recipe developer, and contestant on Bravo's *Top Chef: All Stars LA*. A New Orleans native, Chef Nini combines her Vietnamese heritage with Louisiana influence in her cuisine.

Early in her career, Chef Nini was a pastry chef working in kitchens across New Orleans. She then honed her skills in New York City working at Michelin-star restaurants like Eleven Madison Park. Though cooking is her passion, Chef Nini has fallen in love with teaching and mentoring others in the kitchen. She has developed a cooking school in Brooklyn called Cook Space, which helps home cooks sharpen their cooking skills by teaching techniques from professional kitchens.

Chef Nini is working on her first cookbook, *Đặc Biệt: An Extra-Special Vietnamese Cookbook*, expected to come out Summer 2024.

Kate Orff
is a landscape architect and the founder of SCAPE, a design practice with offices in New York, New Orleans, and San Francisco. She is also a professor at Columbia University Graduate School of Architecture, Planning and Preservation (GSAPP). Kate is the coauthor, with photographer Richard Misrach, of the book *Petrochemical America* (Aperture, 2012). She was named a 2017 MacArthur Fellow.

Jessi Parfait
is a lifelong Louisiana resident and member of the United Houma Nation. Growing up in a small bayou community, she was frequently in the swamps, picking wild blackberries, and developing a love for her home, which continues to influence her work. She earned an MA in anthropology from Louisiana State University where she studied the effects of forced migration on her tribe. She has worked on a number of projects that focus on the human aspects of coastal planning and is passionate about efforts to mitigate the effects of climate change on the Louisiana coast. It is her hope that this place her ancestors have called home for thousands of years may continue to be inhabited well into the future.

Amy Francis Stelly
is an artist, designer, and planner. She is also a preservationist and land use expert who has led some of the city's most powerful advocacy groups. She is a New Orleans native and a resident of the Treme-Lafitte neighborhood.

Amy directs the Claiborne Avenue Alliance Design Studio, a nonprofit born out of the advocacy work of the alliance. Founded in 2022, the studio is a community-based architectural and urban design firm that is committed to providing access to the languages of design and land use for all.

Amy has written about land use and zoning; the value of community engagement; and public account-ability. Her work has appeared in the *Washington Post*, Strong Towns, *Common Edge*, the *Lens*, and the *Interstate*. Amy is an avid swimmer and advocate for water safety and environmental stewardship.

Jonathan Tate
is principal of OJT (Office of Jonathan Tate), an architecture and urban design practice in New Orleans. The office, in addition to normative architectural work, concerns itself with investigations and initiatives centered on topics of relevance to the development of contemporary built environments. This work has received numerous awards, including National AIA Housing Awards and the National AIA Honor Award in Architecture. The office received an Emerging Voices award in 2017 from the Architectural League of New York. Tate is the recipient of the 2020 Award in Architecture from the American Academy

of Arts and Letters. He has held faculty positions at Tulane University and the Cooper Union.

Aaron Turner
is a photographer and educator currently based in Arkansas. He uses photography as a trans-formative process to understand the ideas of home and resilience in two main areas of the US, the Arkansas and Mississippi River Deltas. Aaron also uses the 4×5 view camera to create still life studies on identity, history, Blackness as material, and abstraction. Aaron received an MA from Ohio University and an MFA from Mason Gross School of the Arts at Rutgers University. He was a 2018 Light Work Artists-in-Residence at Syracuse University, a 2020 Visual Studies Workshop Project Space Artists-in-Residence, a 2020 Artists 360 Mid-America Arts Alliance grant recipient, the 2021 Houston Center for Photography Fellowship recipient, and 2022 Darryl Chappell Foundation photographer-in-residence at Ogden Museum of Southern Art. He is the founder/director of the Center for Art as Lived Experience in the School of Art at the University of Arkansas.

John Verdin
is a lifelong resident of Louisiana. He lives in Terrebonne Parish with his family where he enjoys spending time fishing, shrimping, and hunting.

Columbia Books on Architecture and the City
An imprint of the Graduate School of
Architecture, Planning, and Preservation

Columbia University
415 Avery Hall
1172 Amsterdam Ave
New York, NY 10027

arch.columbia.edu/books
Distributed by Columbia University Press
cup.columbia.edu

*Into the Quiet and the Light: Water, Life,
and Land Loss in South Louisiana*
By Virginia Hanusik
With Richie Blink, Imani Jacqueline Brown,
Jessica Dandridge, Rebecca Elliott, Michael
Esealuka, T. Mayheart Dardar, Billy Fleming,
Andy Horowitz, Arthur Johnson, Louis
Michot, Nini Nguyen, Kate Orff, Jessi Parfait,
Amy Francis Stelly, Jonathan Tate, Aaron
Turner, and John Verdin.

ISBN: 978-1-941332-82-5
Library of Congress Control Number:
2024931379

Graphic Design: New Information
David Yun, Inyeong Cho
Lithographer: Marjeta Morinc
Copyeditor: Louisa Nyman
Printer: Musumeci
Paper: Arctic Matt, Munken Kristall
Type: Berthold Garamond

This book has been produced through the Office
of the Dean, Andrés Jaque, and the Office of
Publications at Columbia University GSAPP.

Director of Publications: Isabelle Kirkham-Lewitt
Assistant Director: Joanna Joseph
Assistant Editor: Meriam Soltan